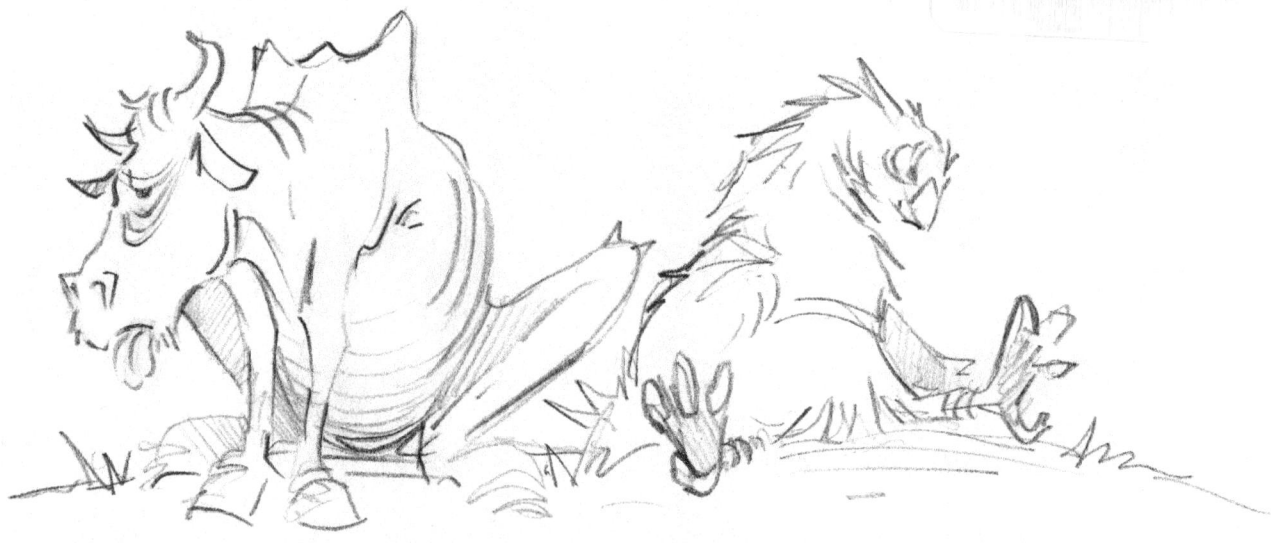

Copyright © 2015 by Robert Hohreiter

All rights reserved. This book or any portion thereof may not be reproduced or used in any manner whatsoever without the express written permission of the publisher

Published by Robert Hohreiter and Lulu.com

E-Mail robert@roberthohreiter.com

ISBN 978-1-329-17378-1

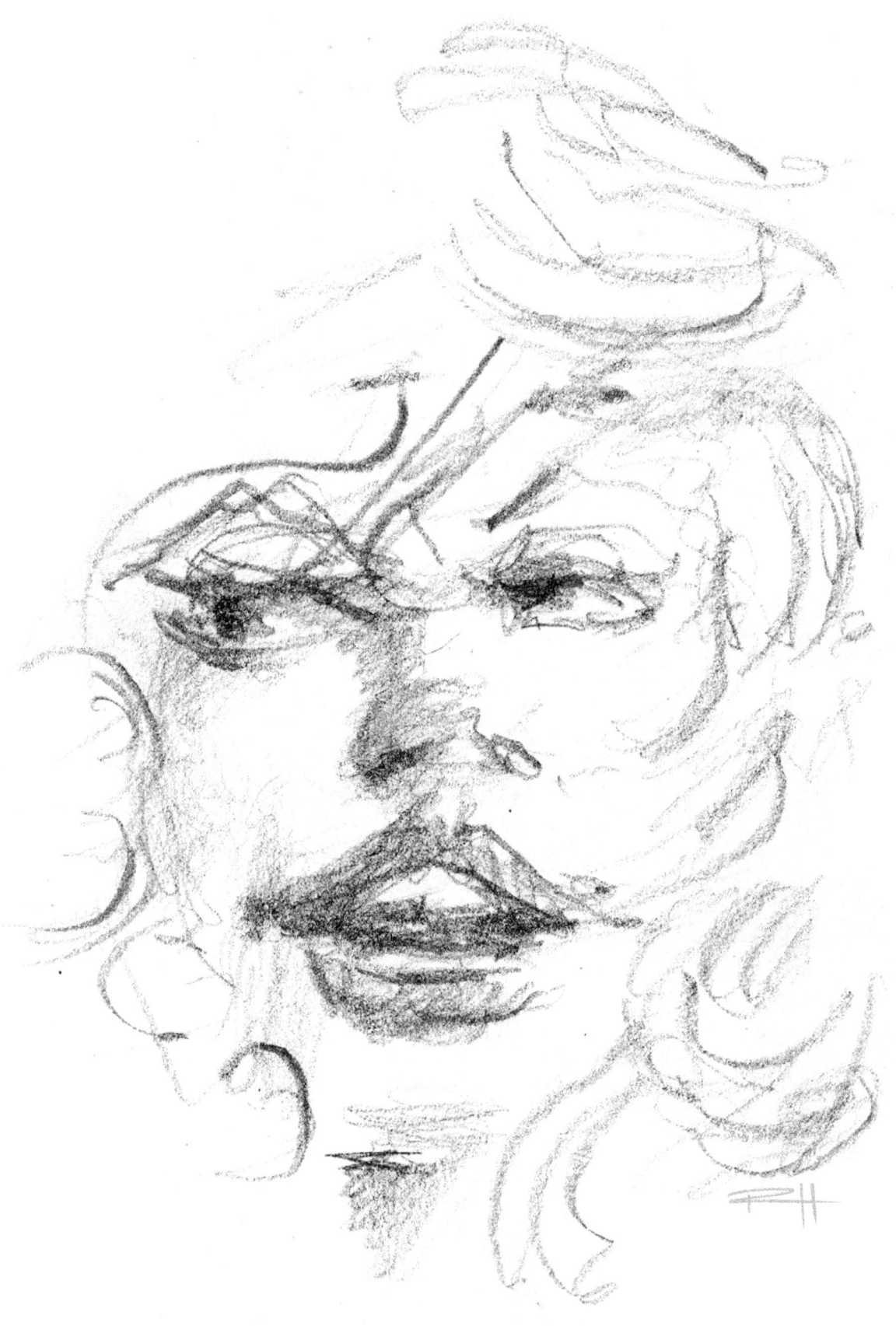

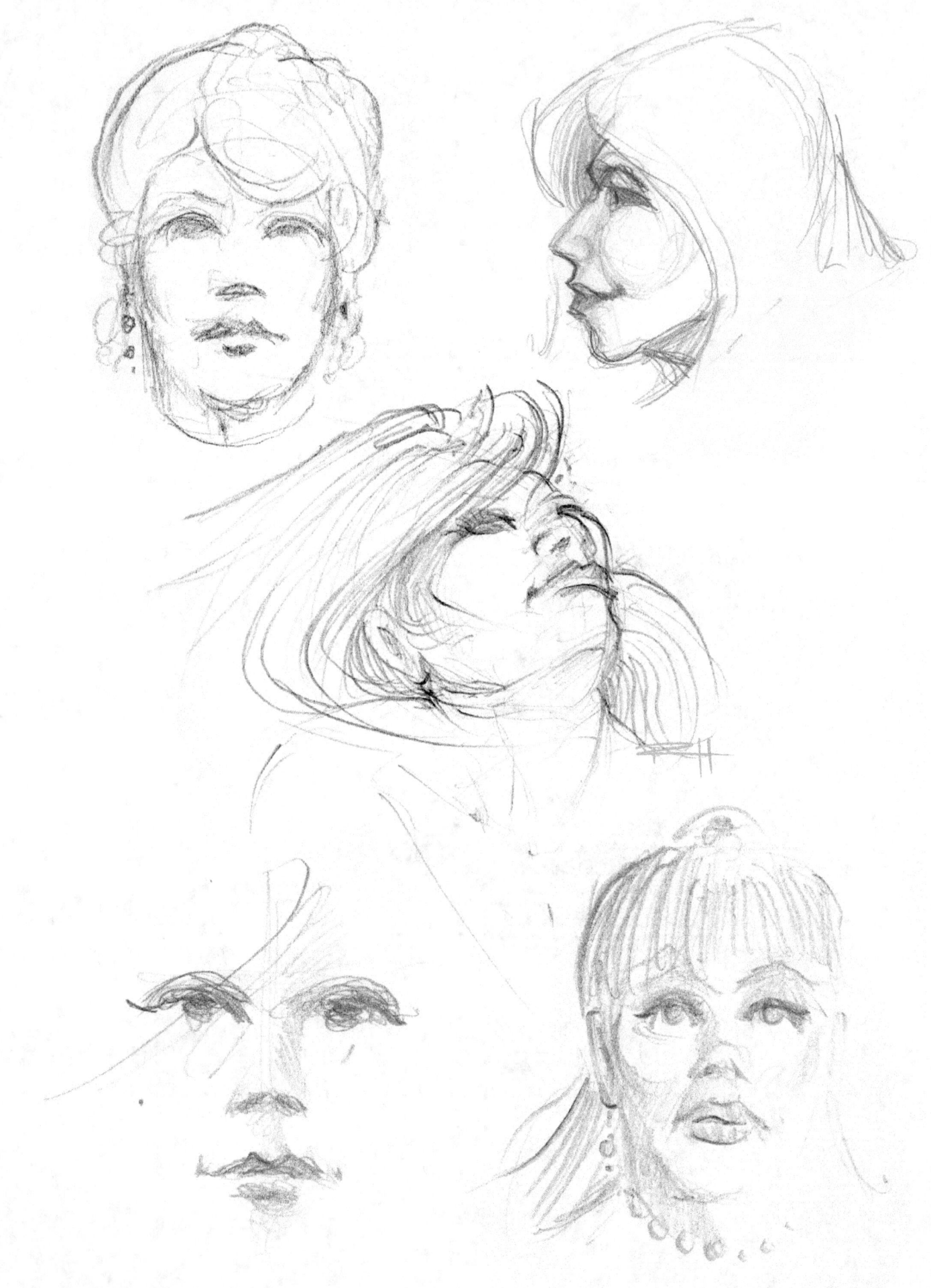

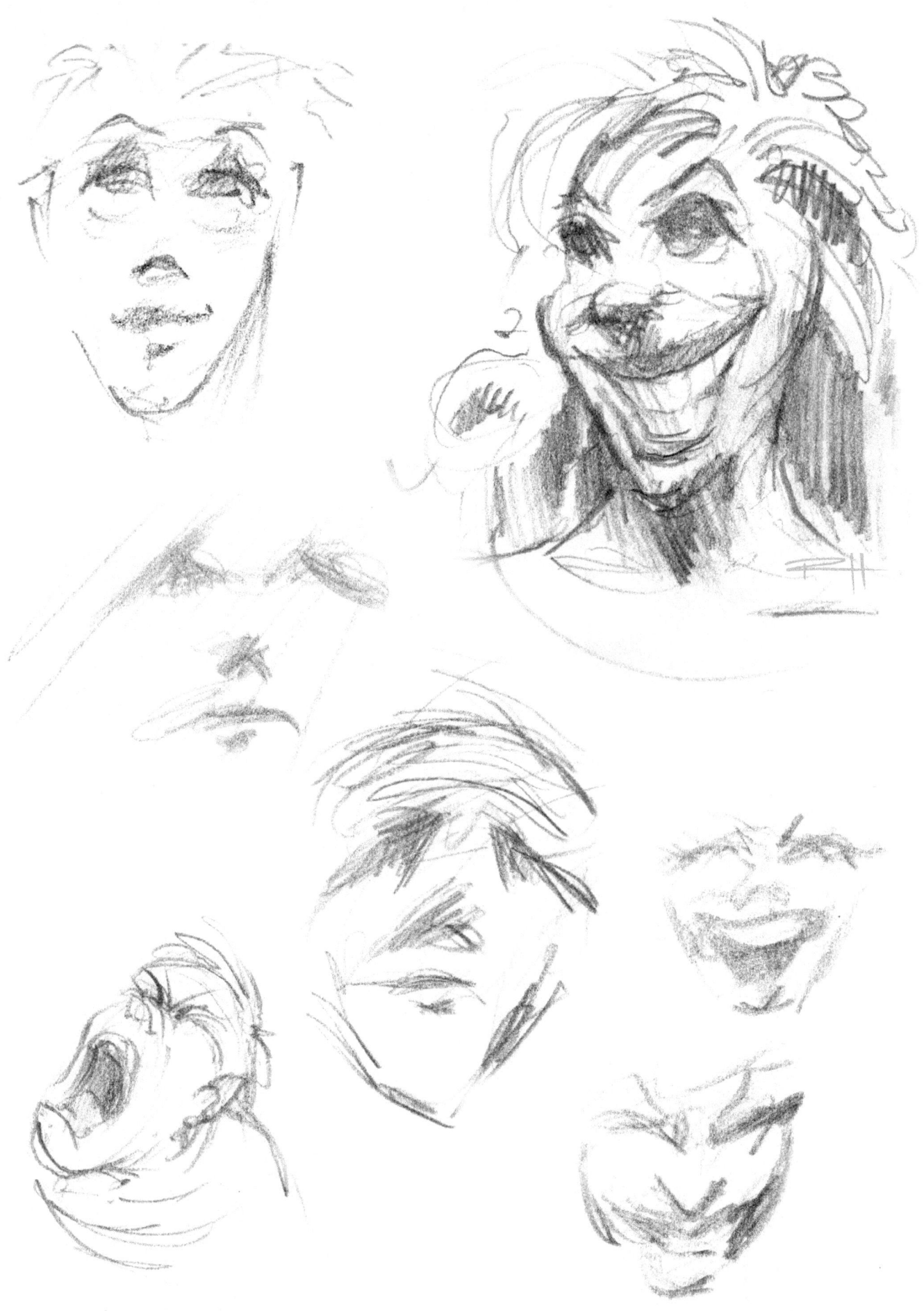

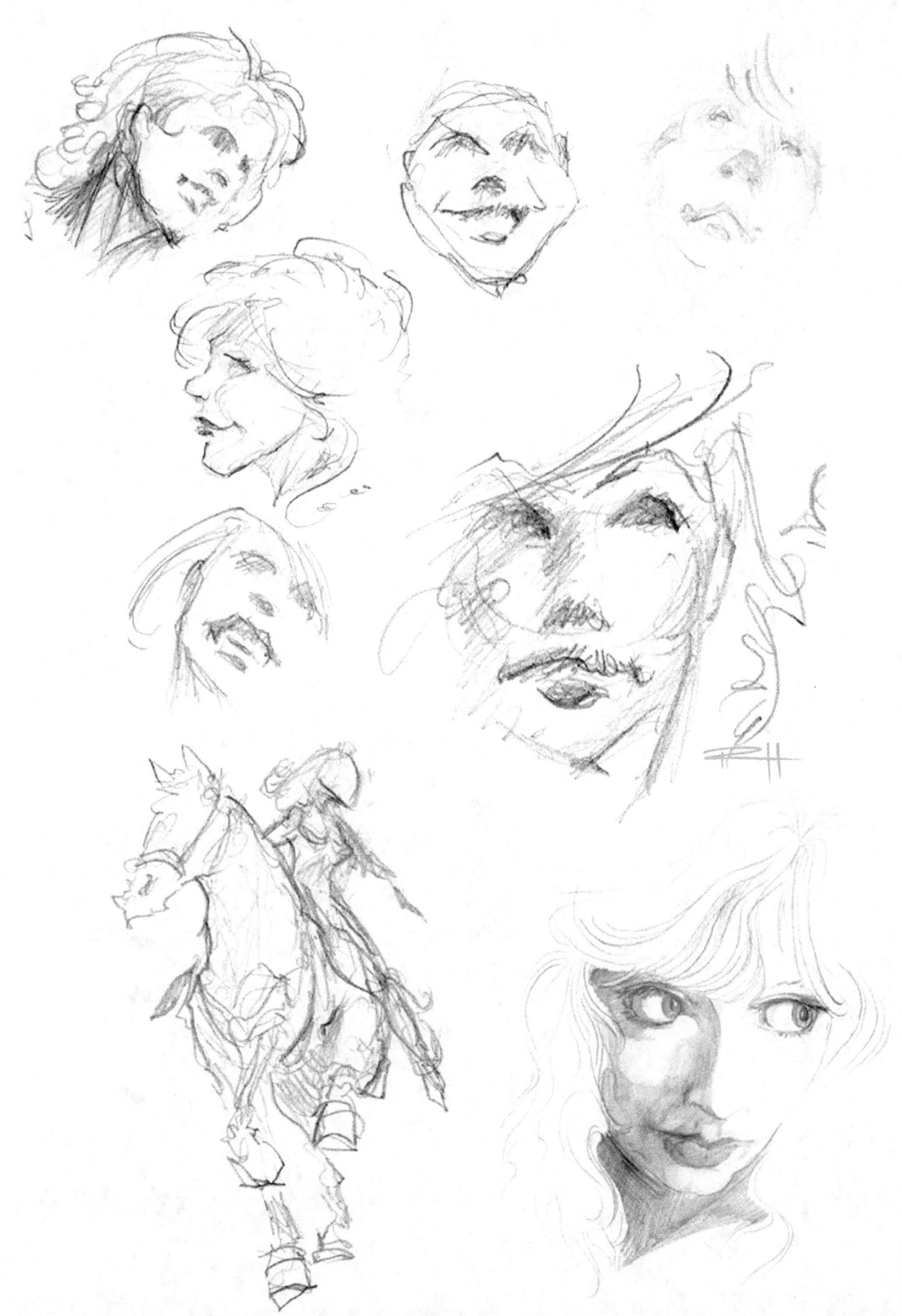

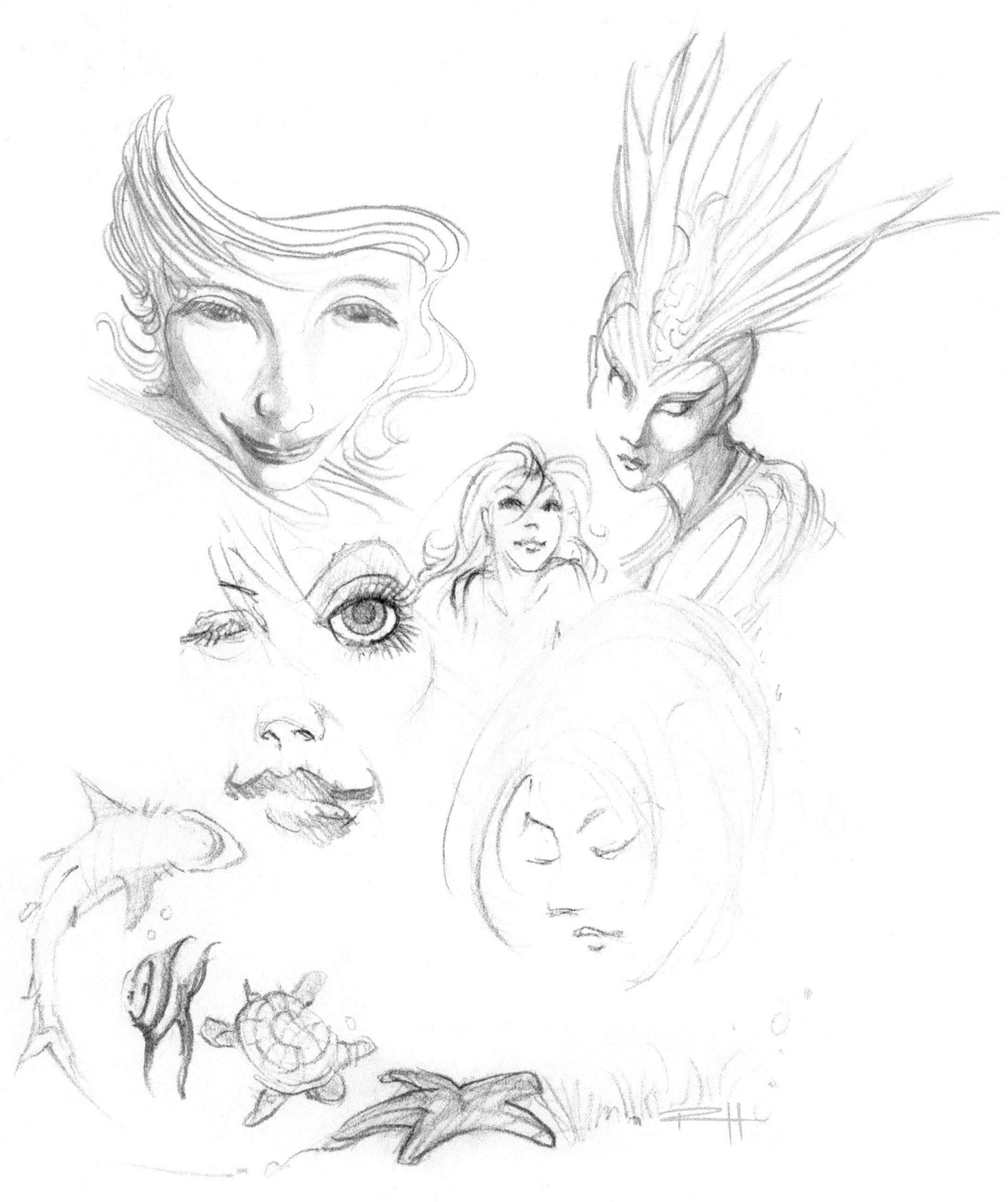

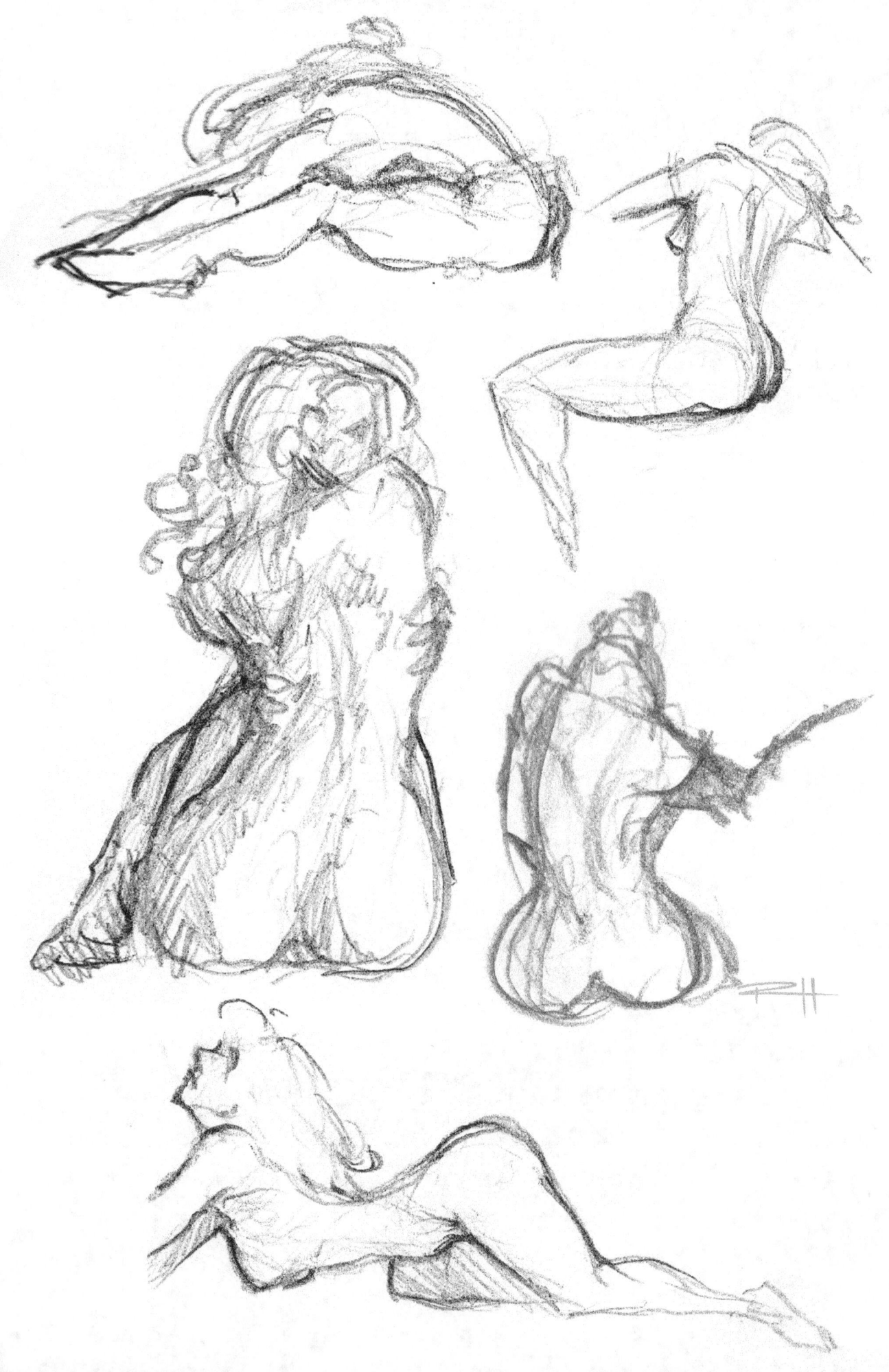

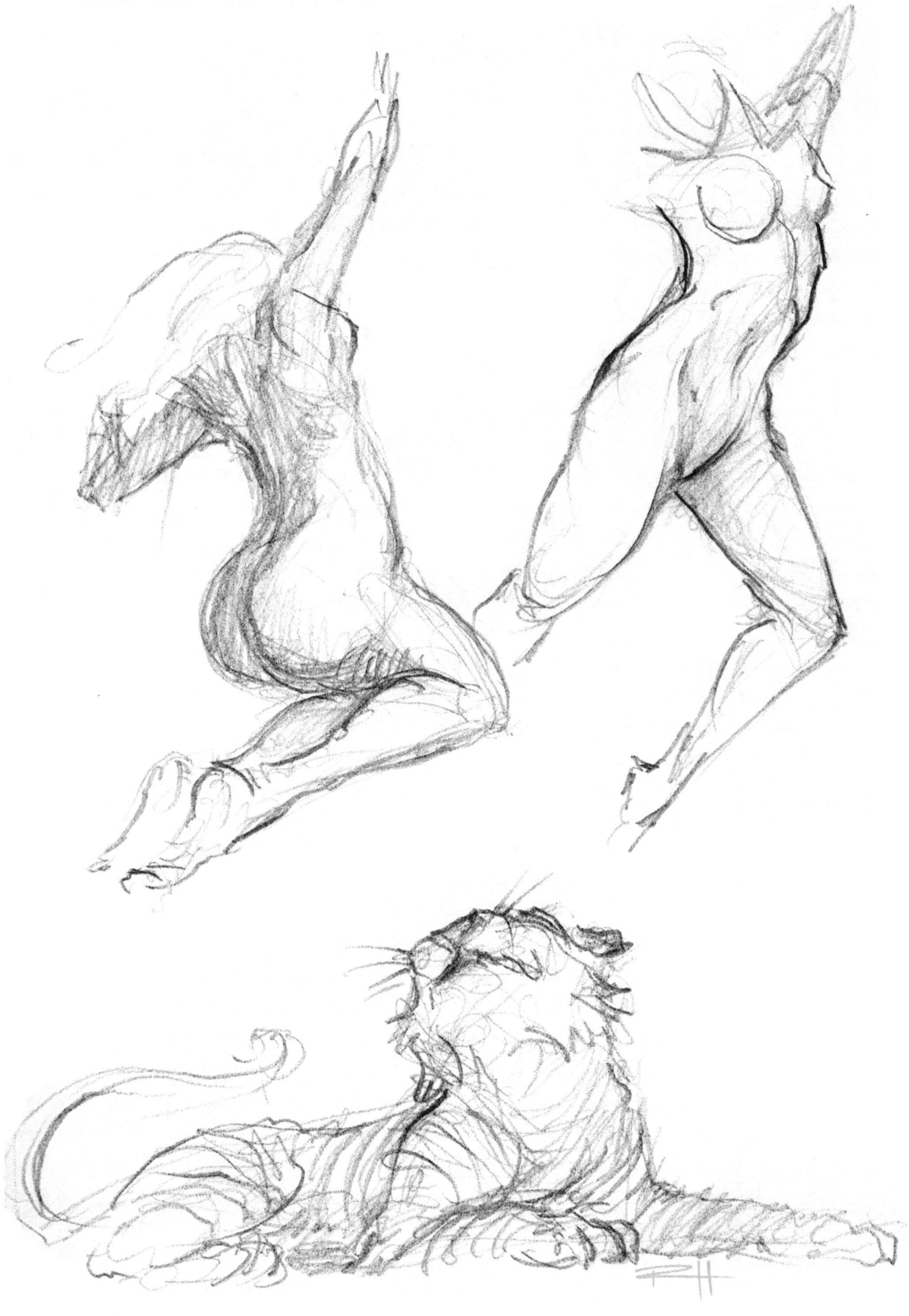

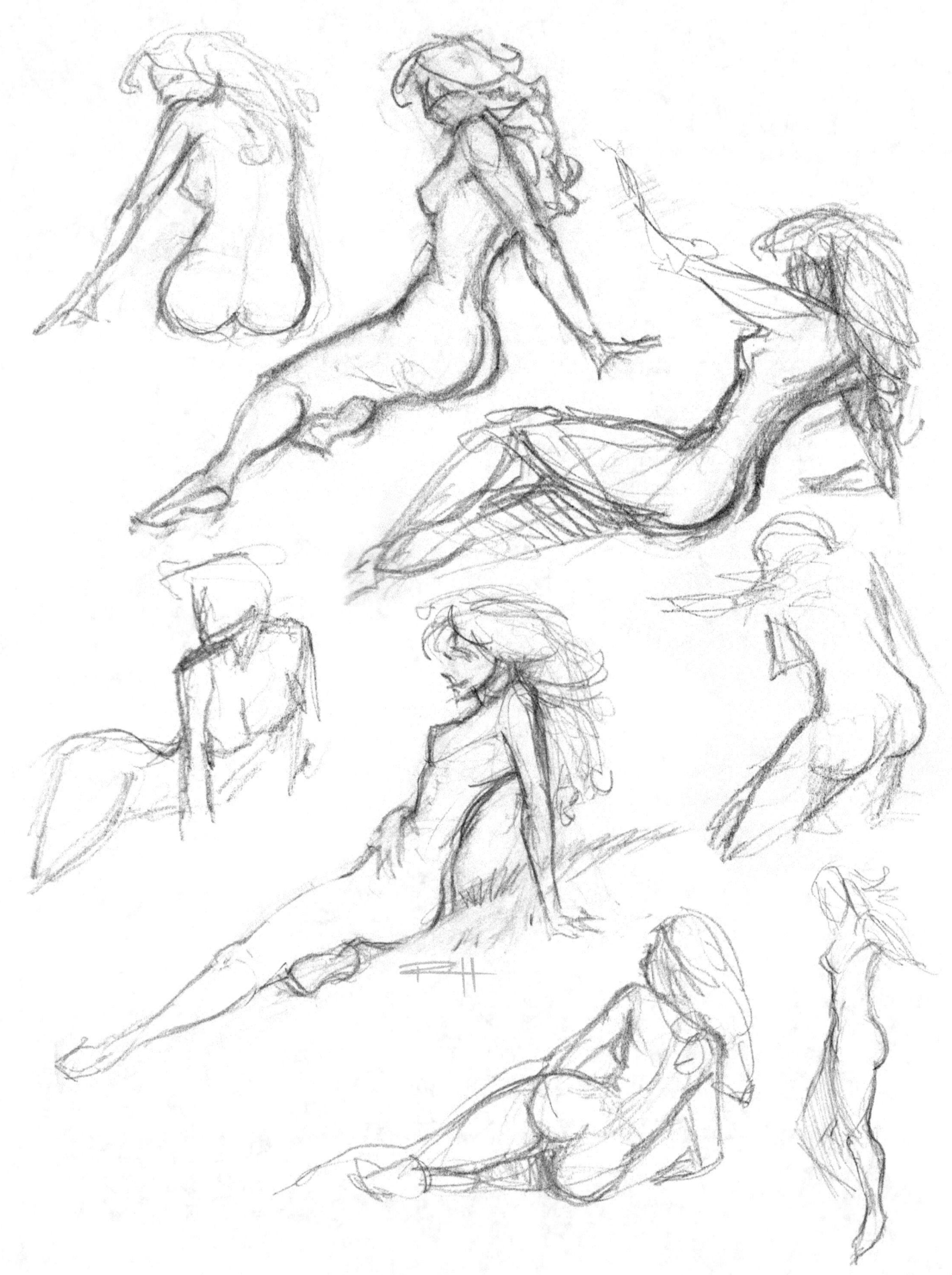

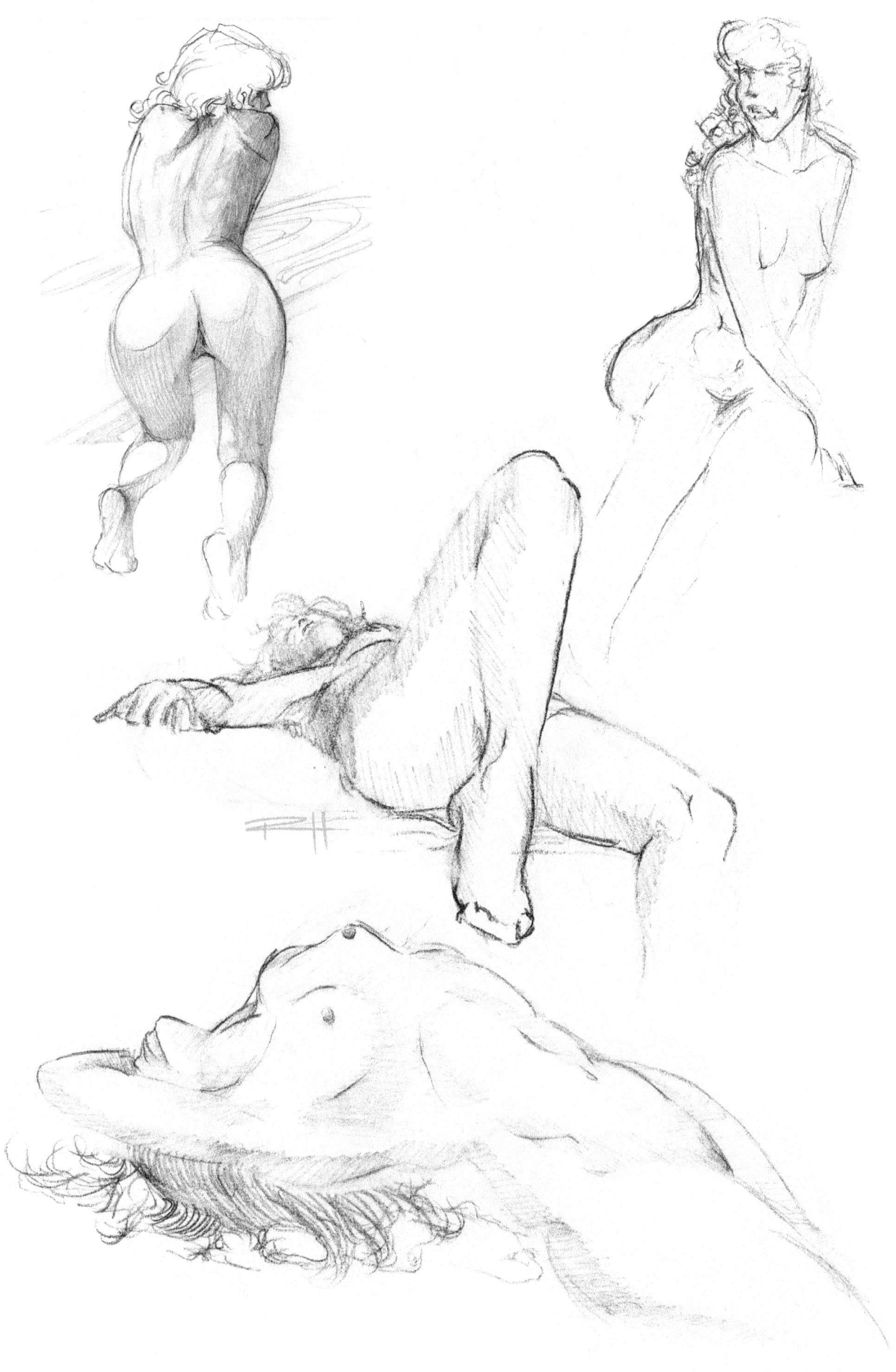

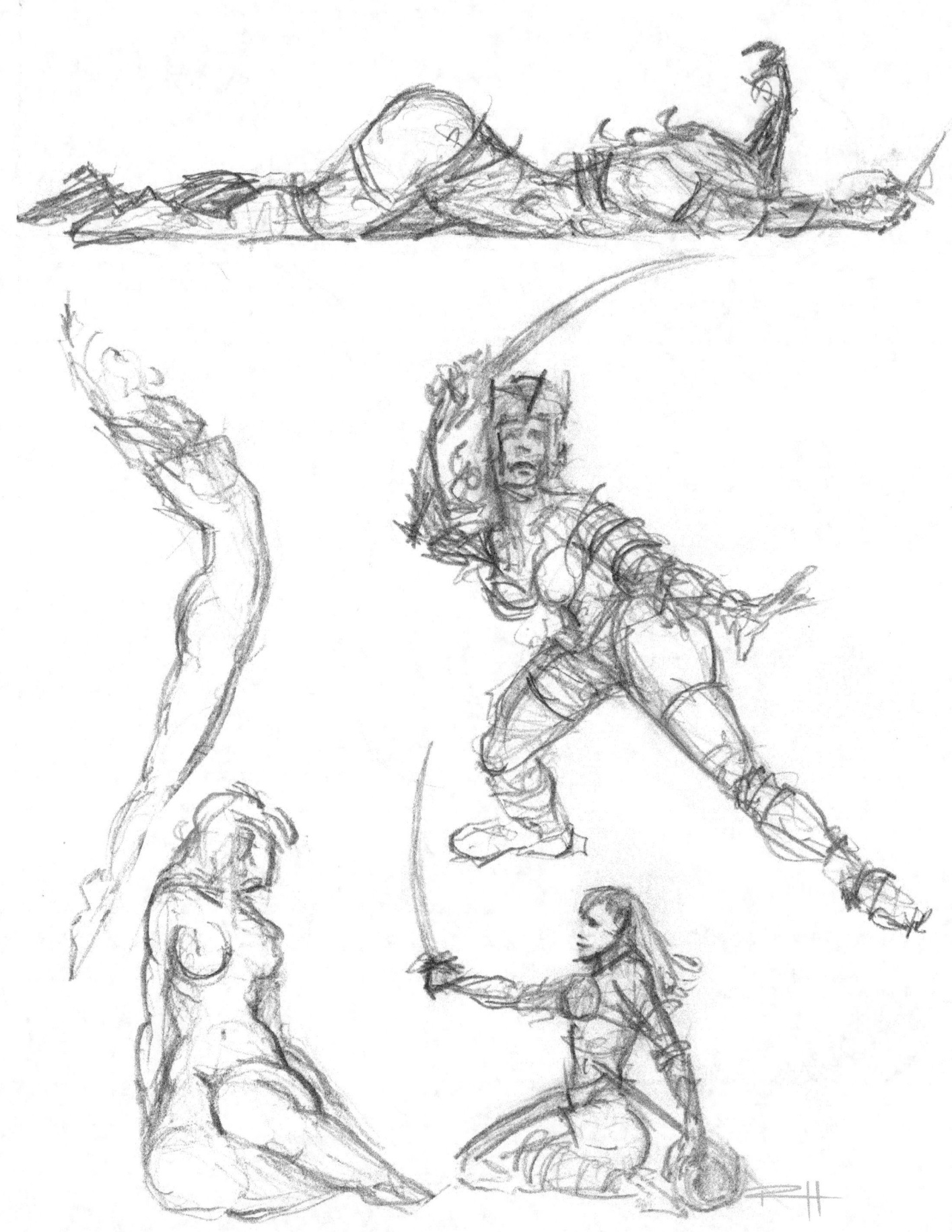

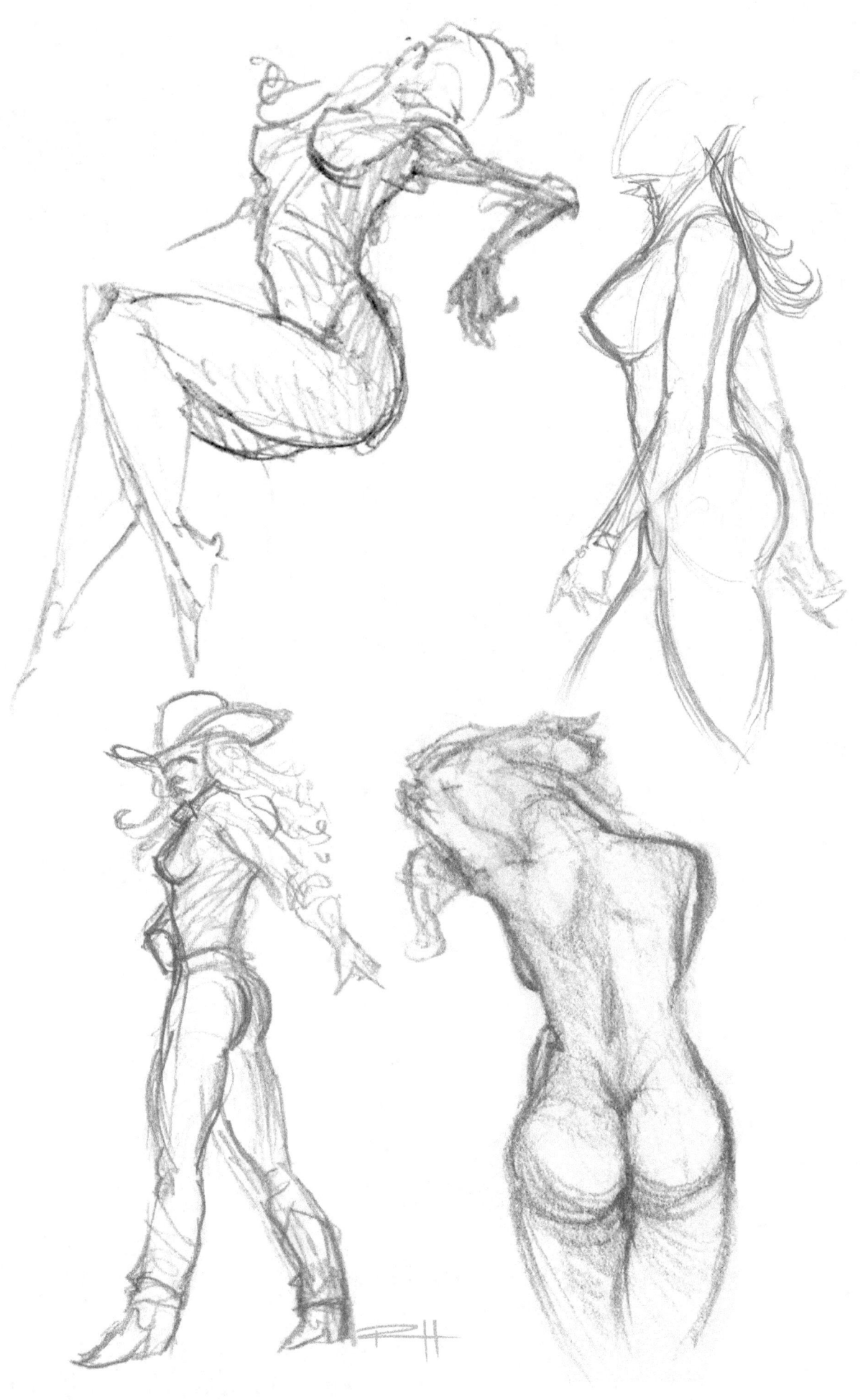

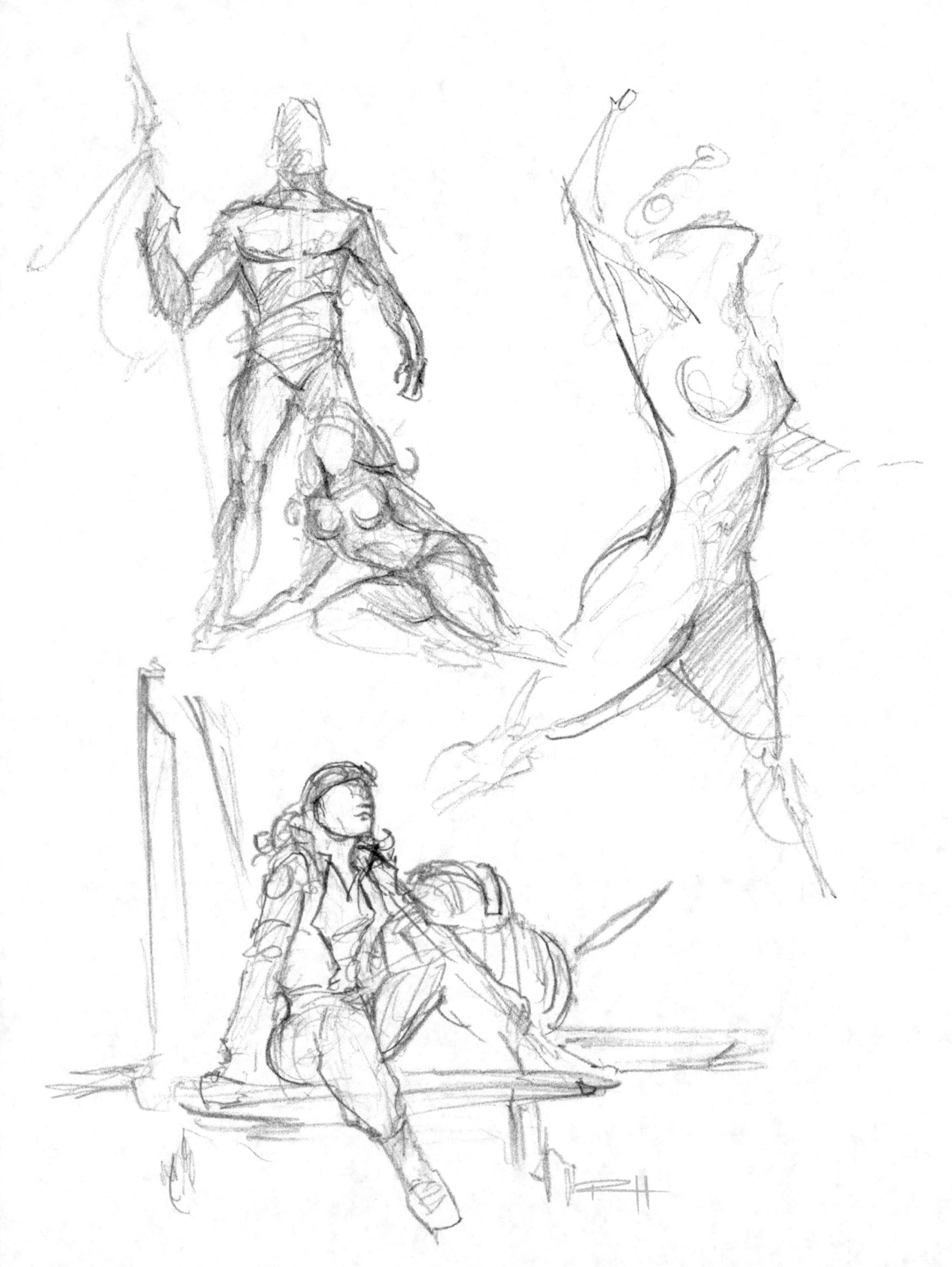

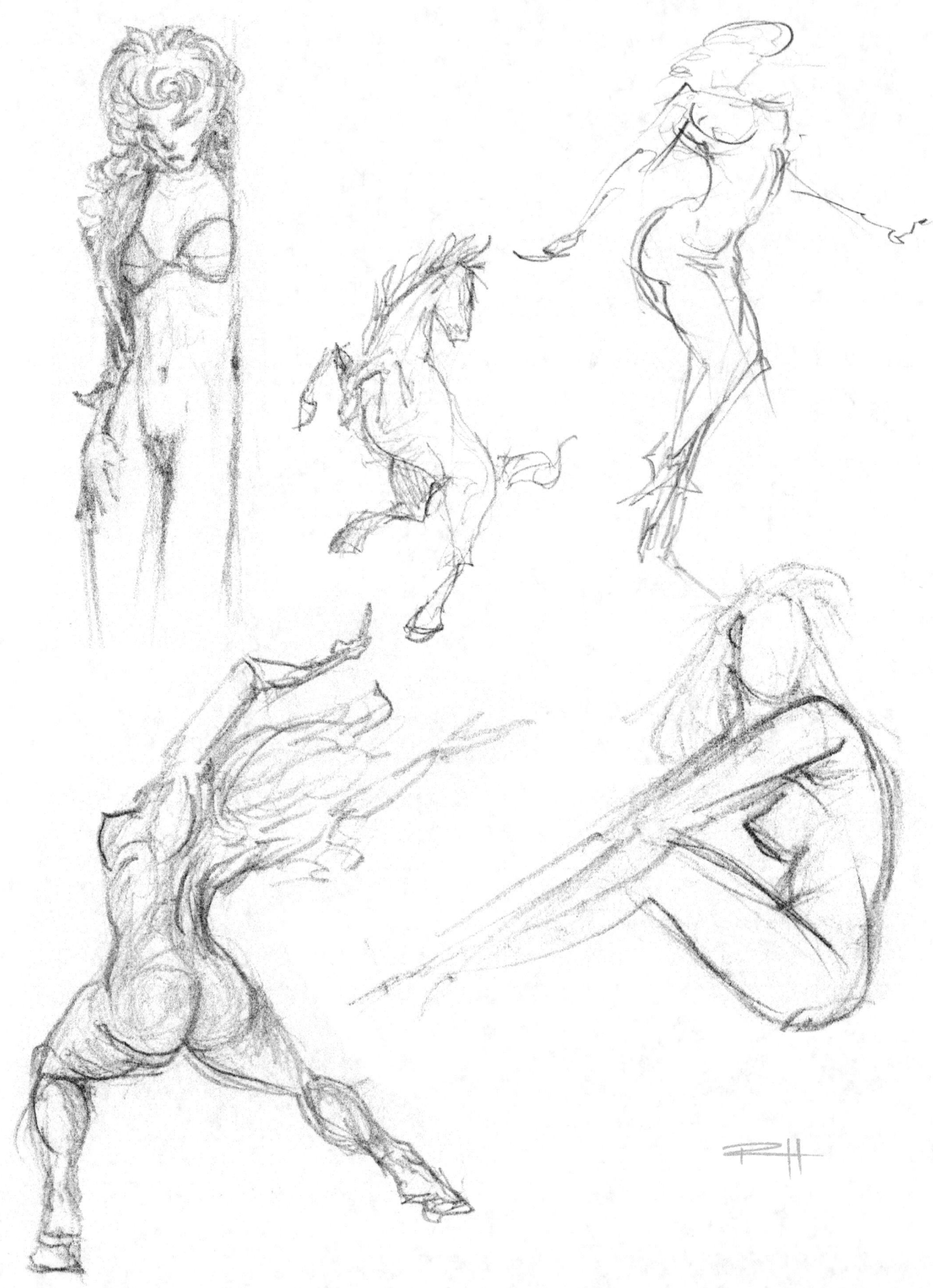

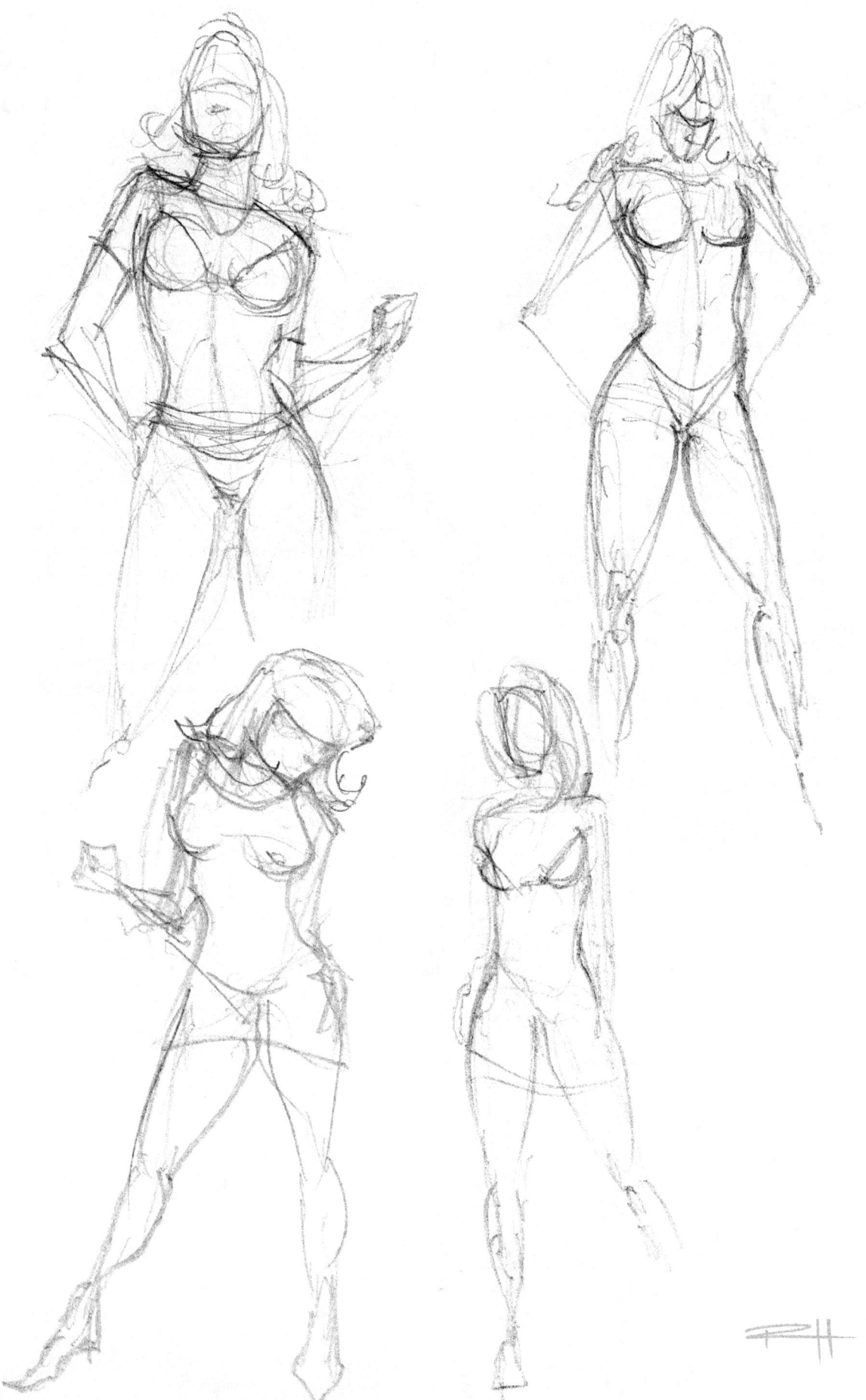

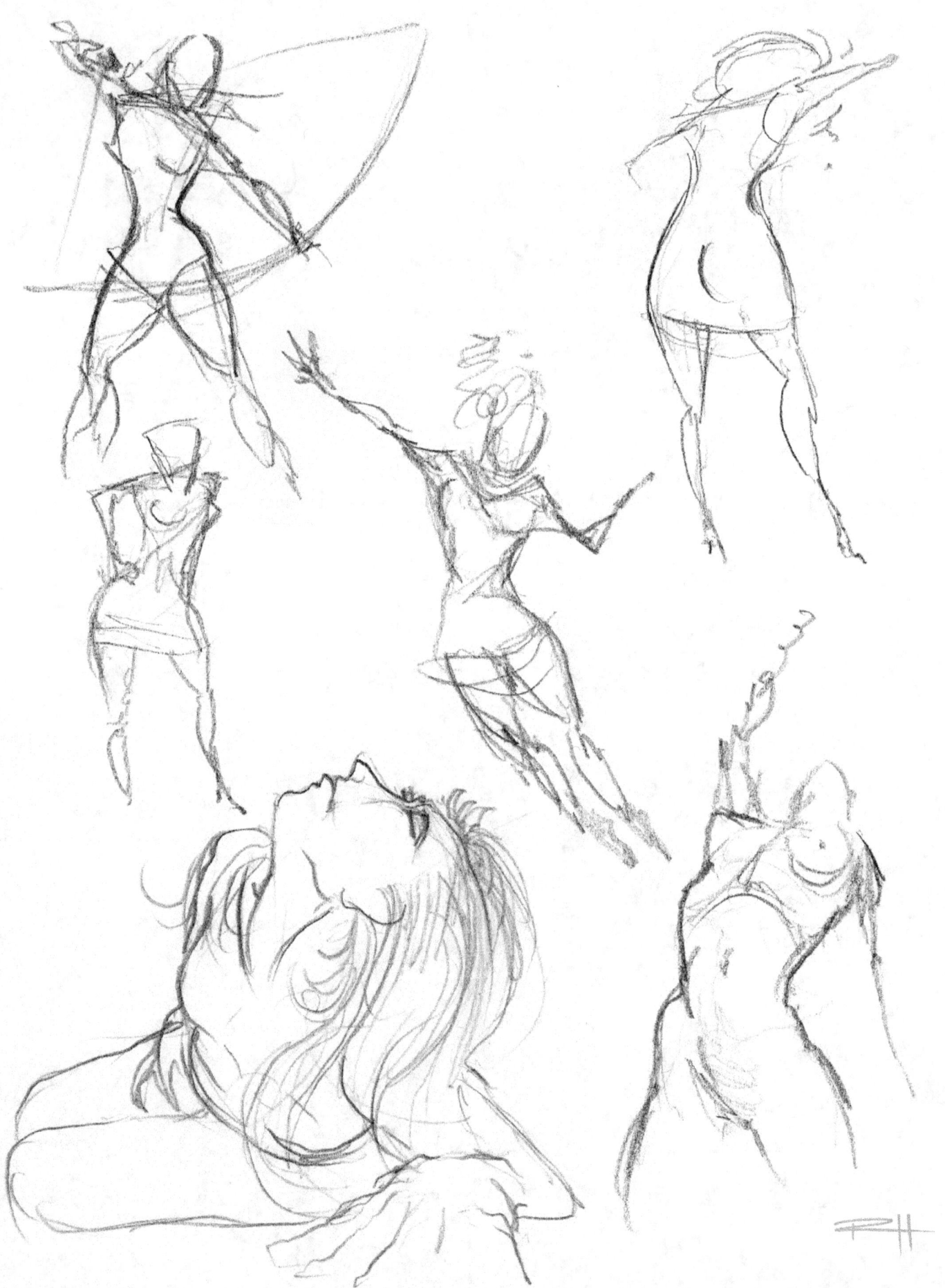

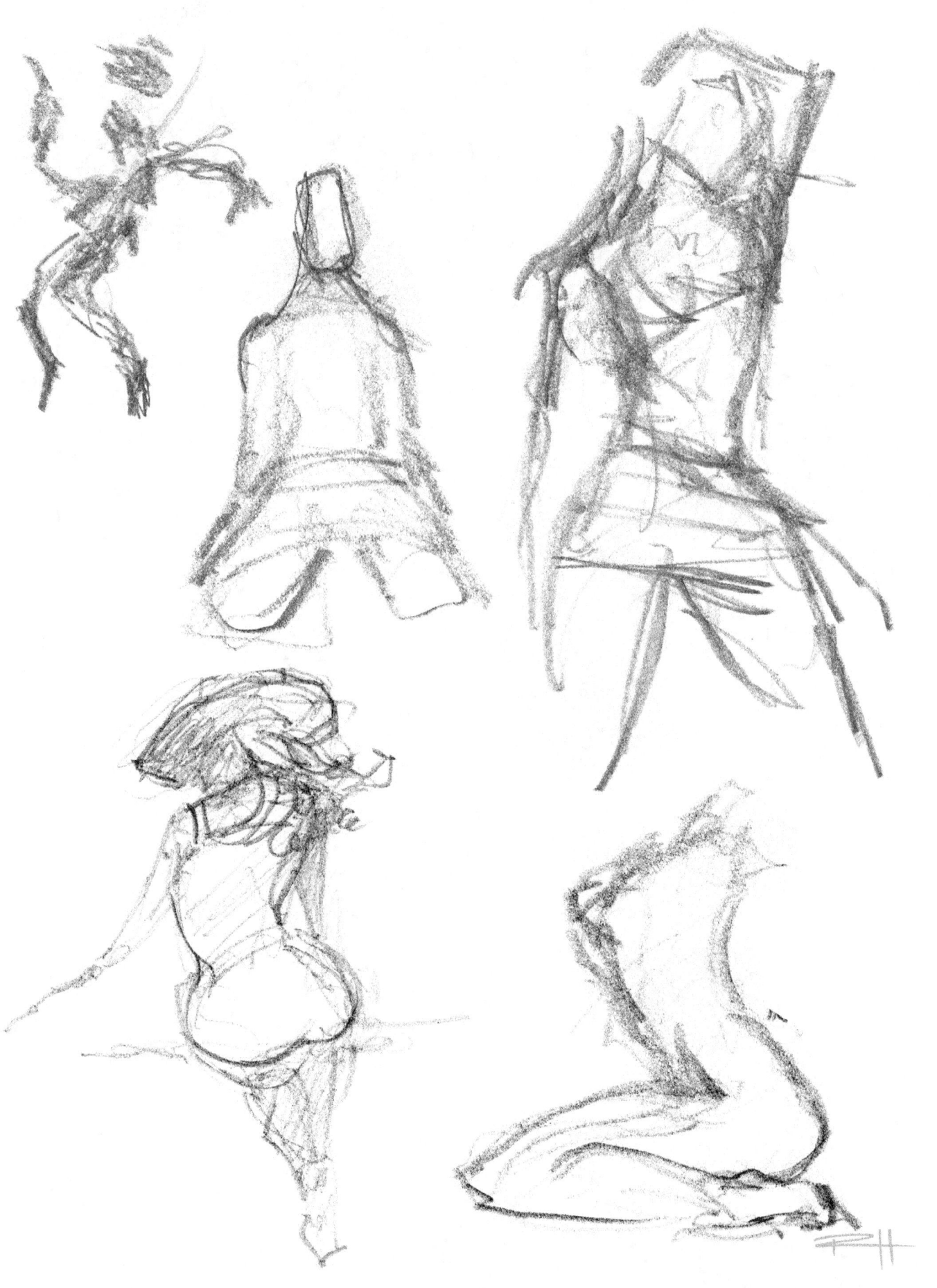

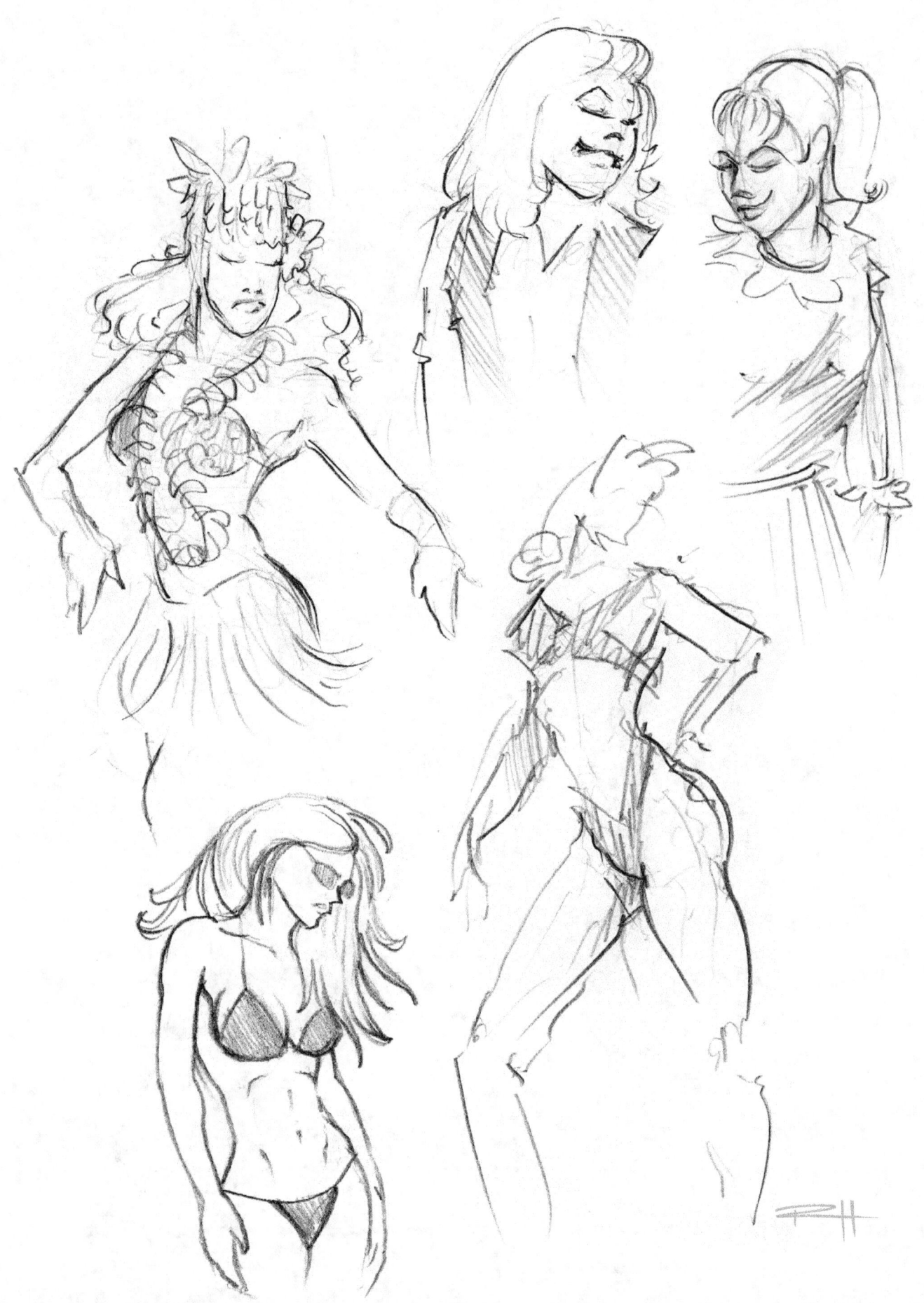

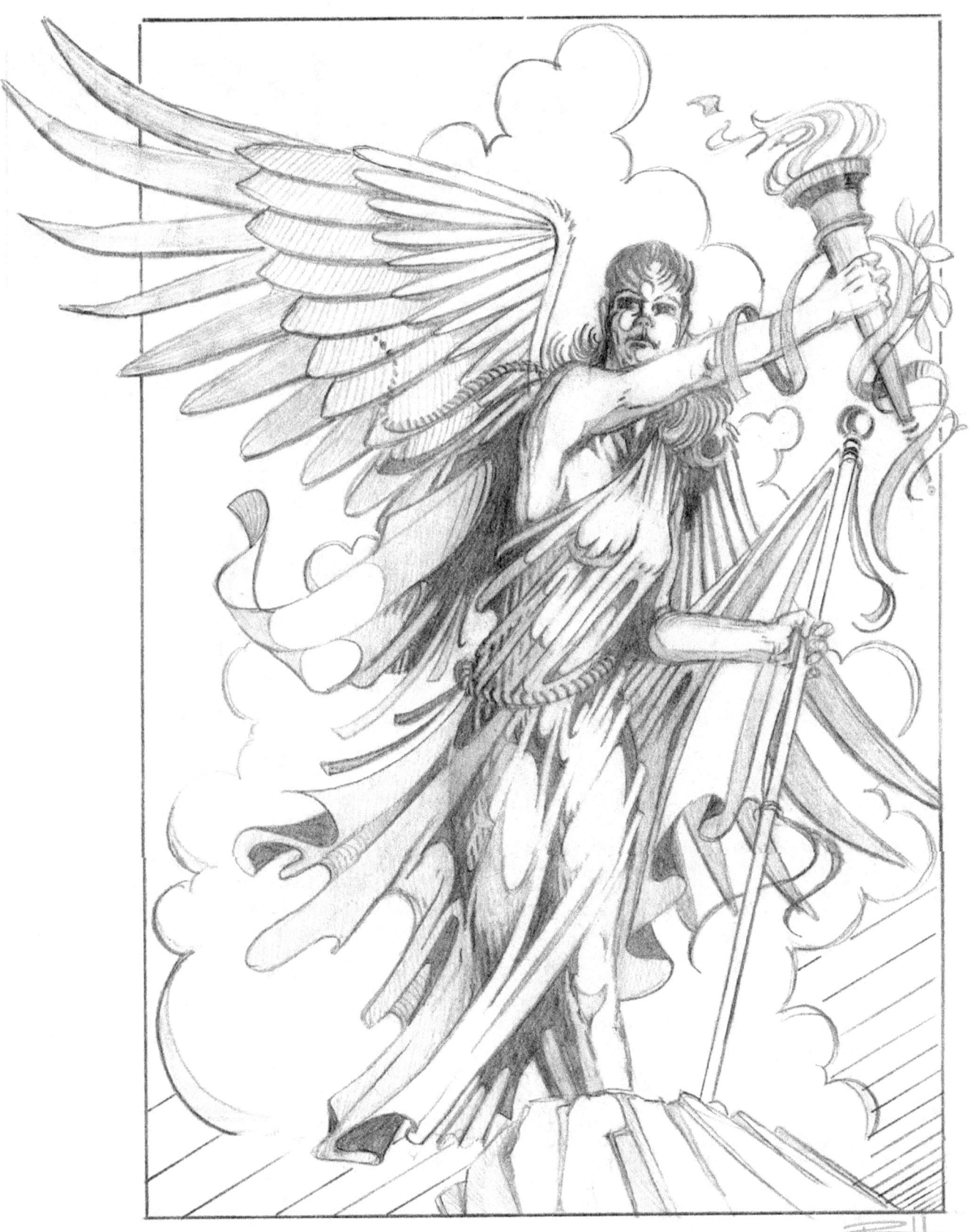

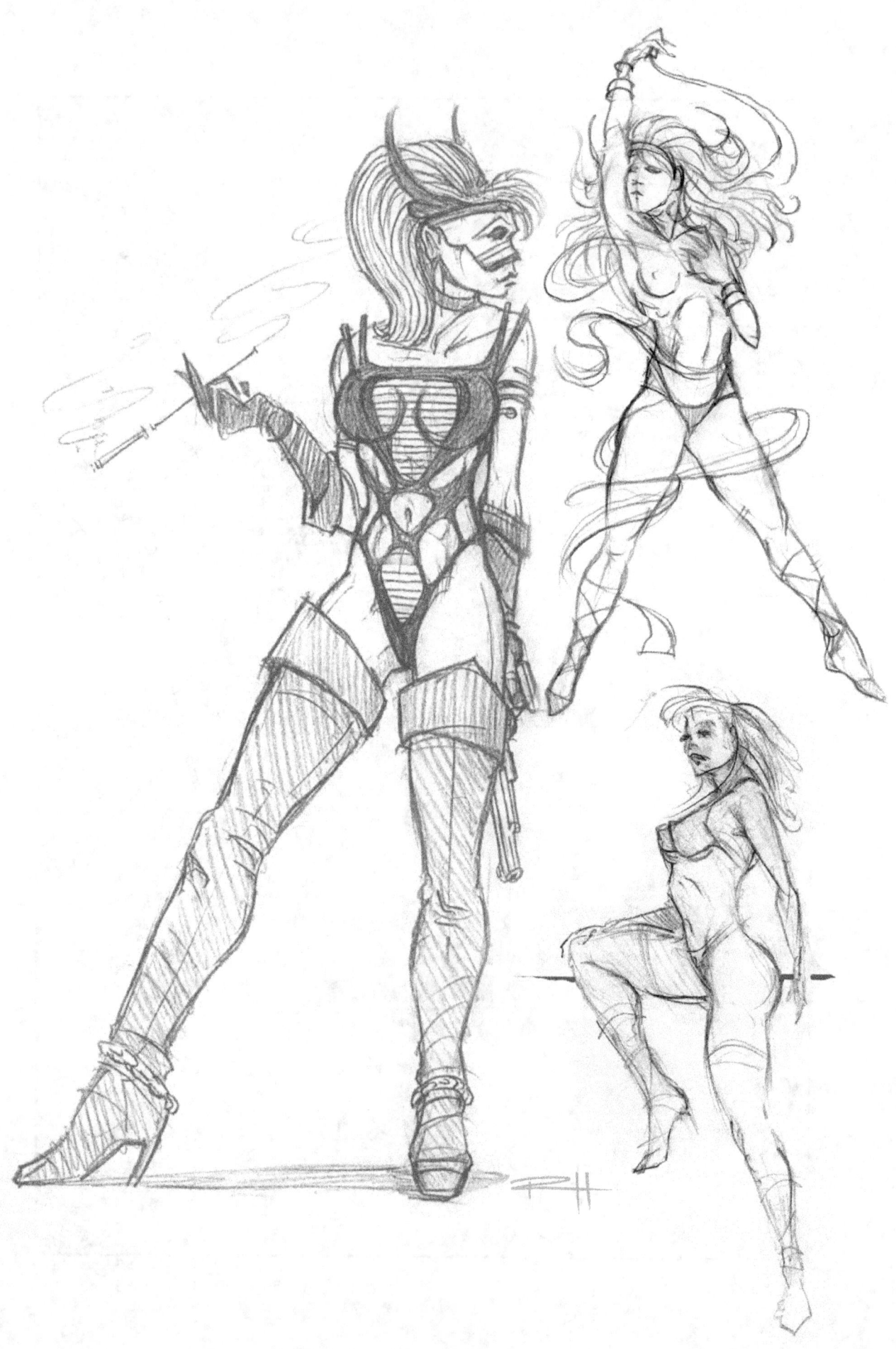

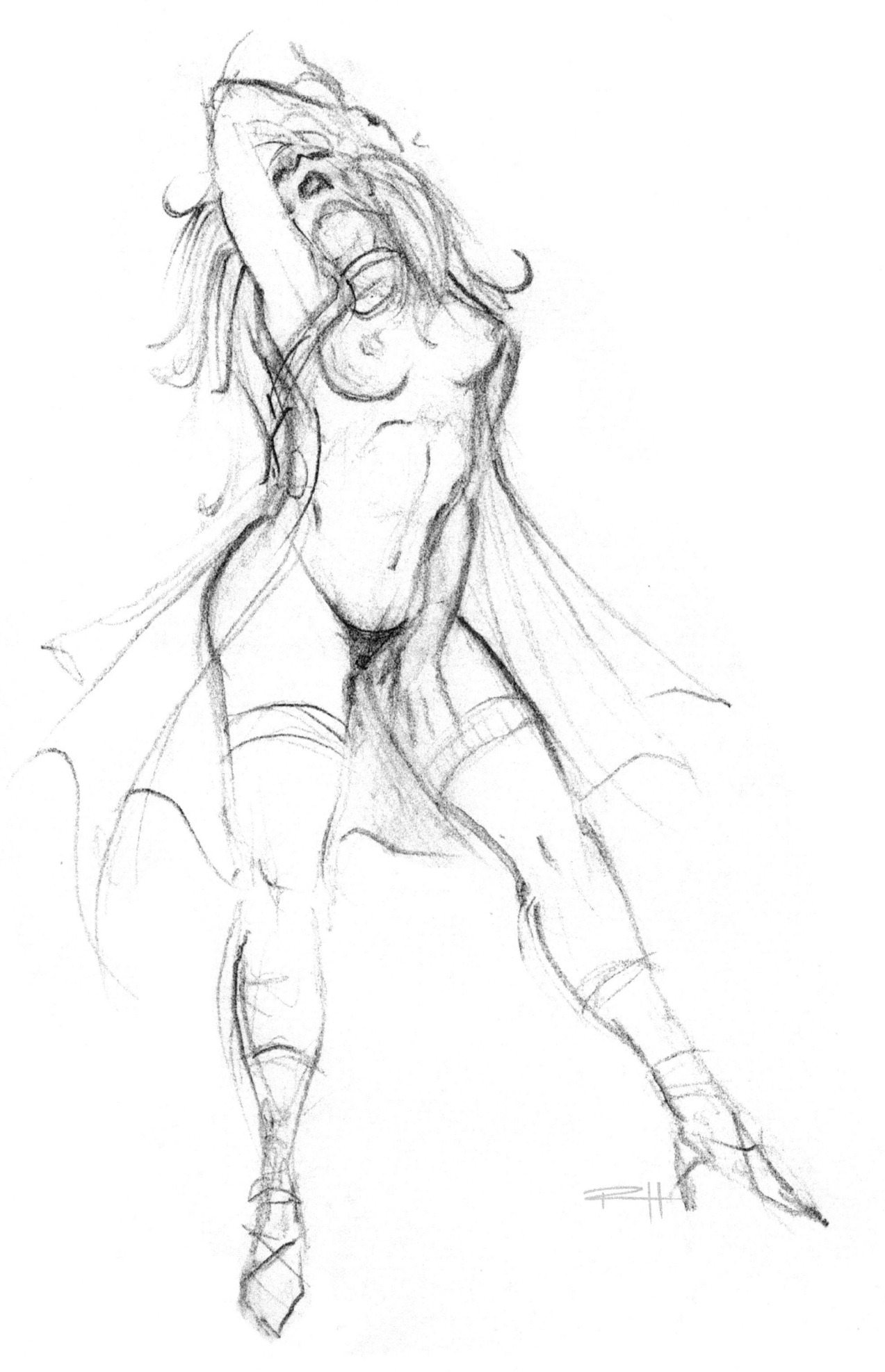

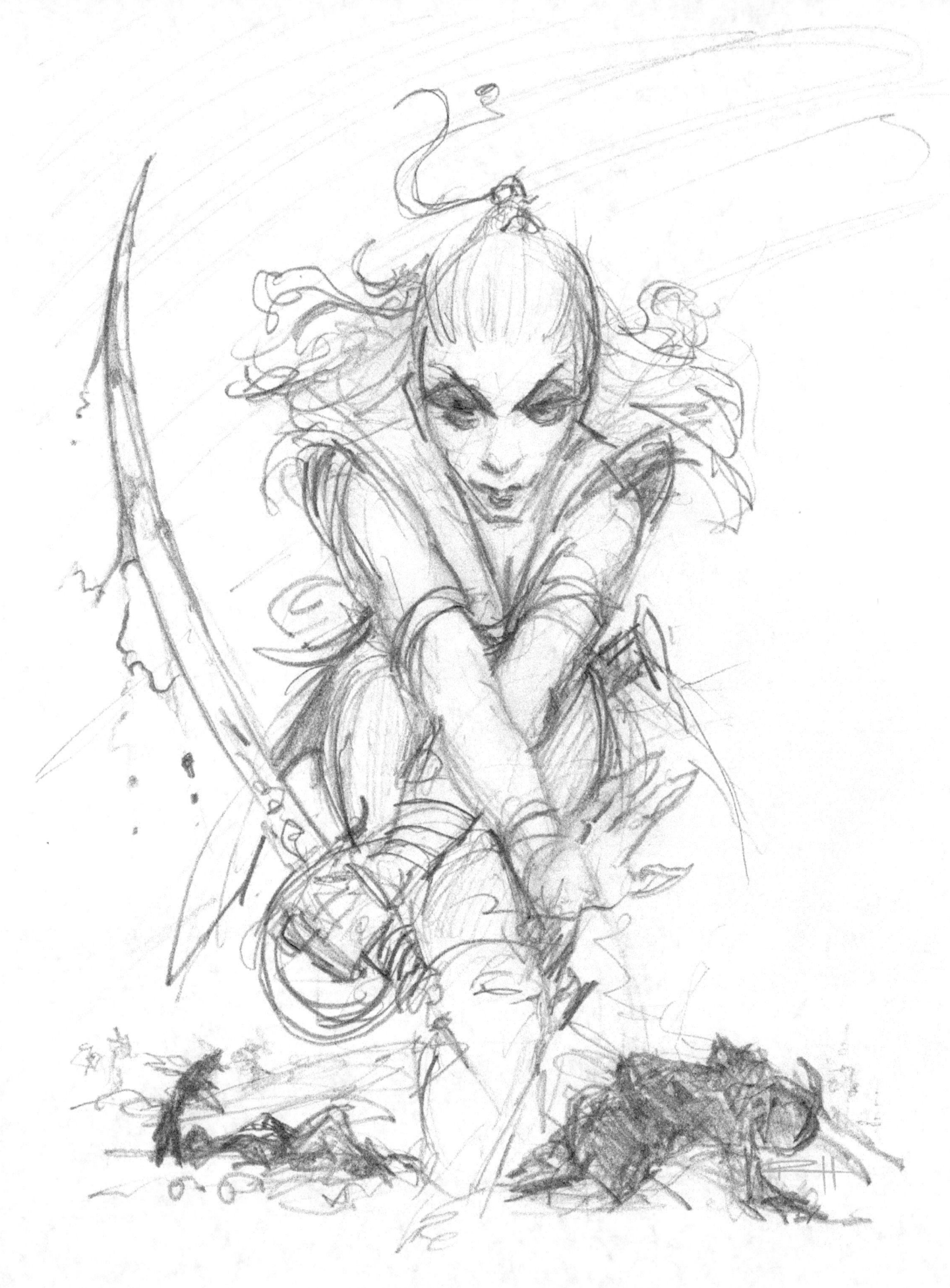

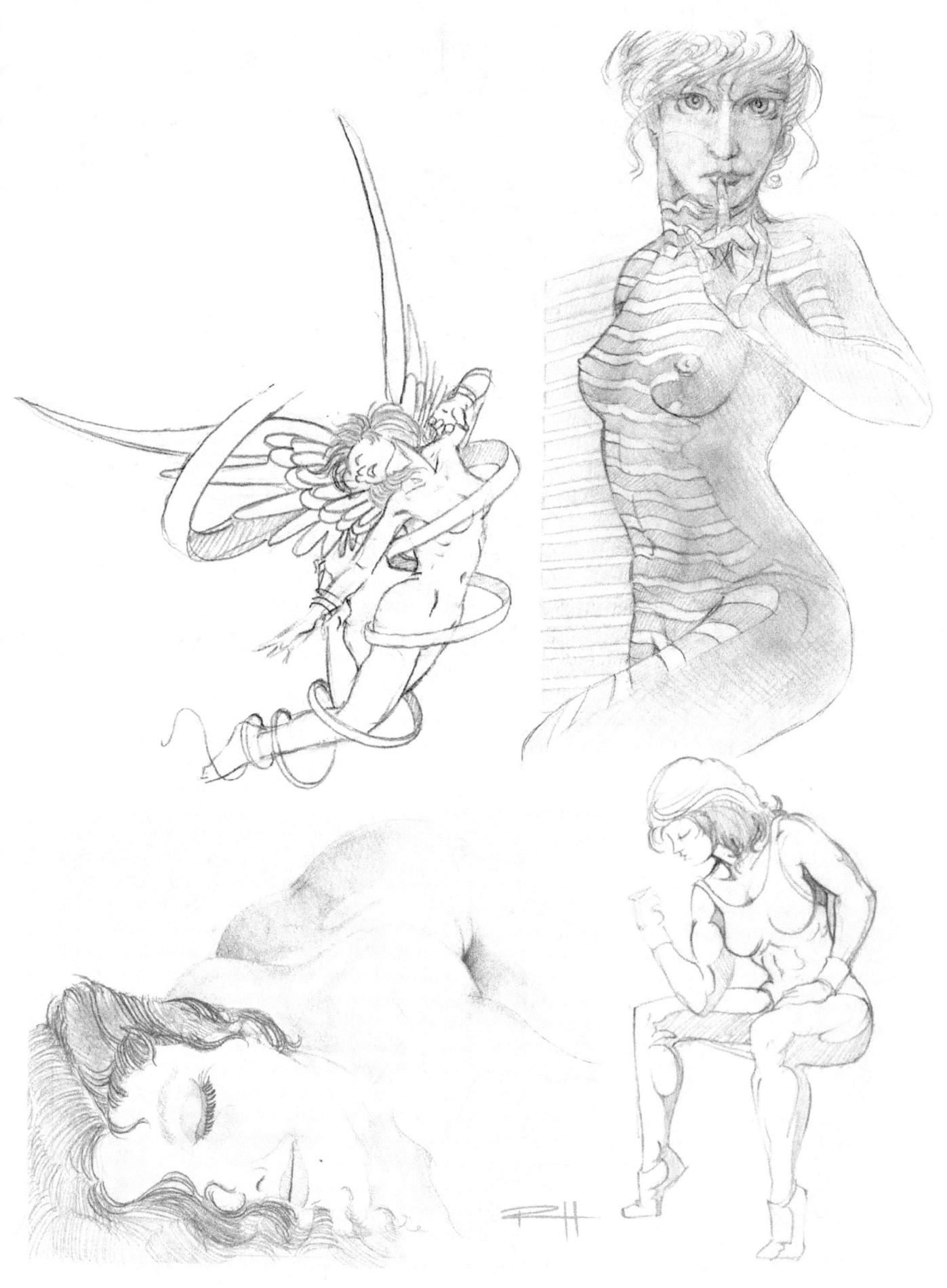

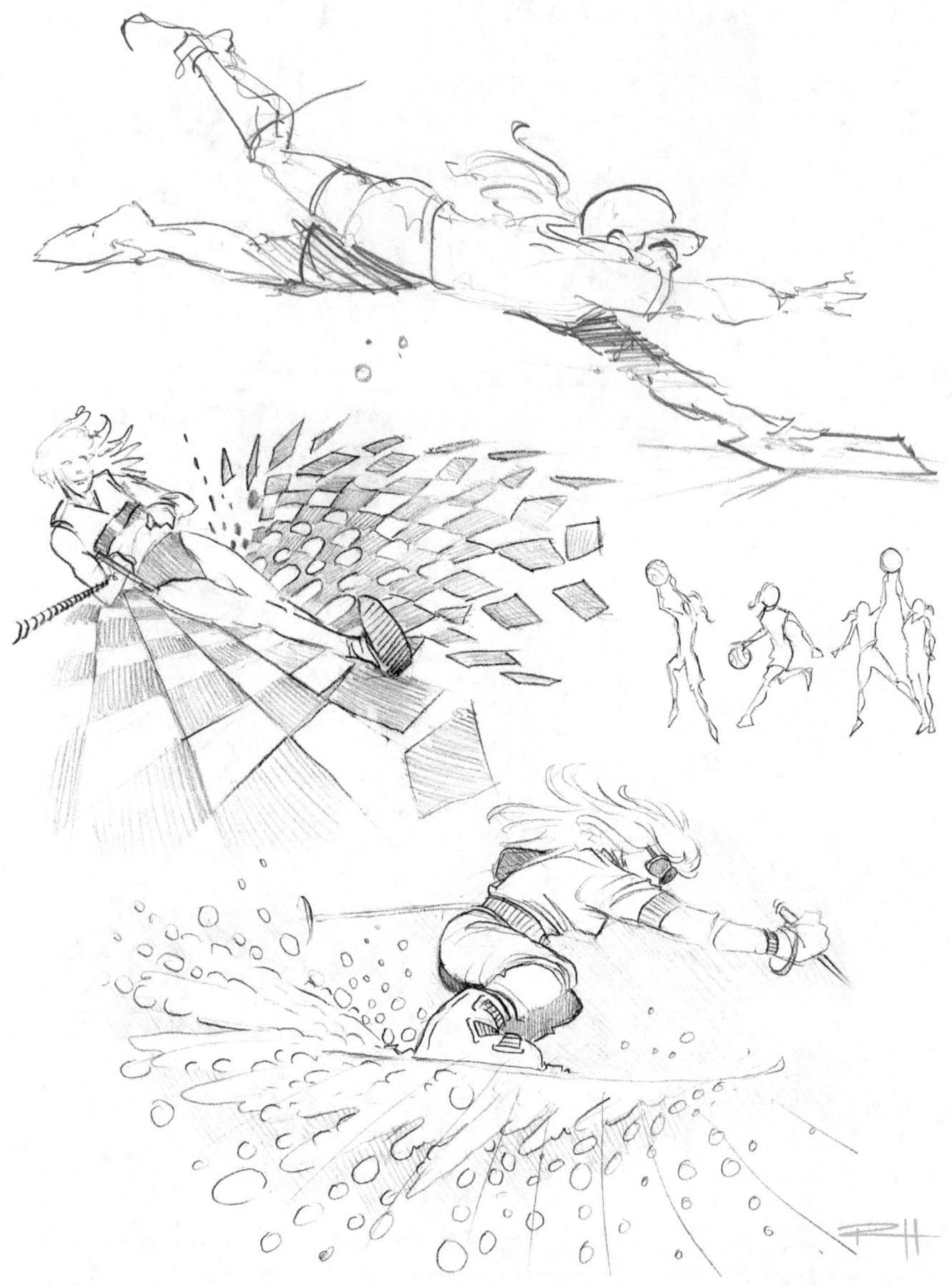

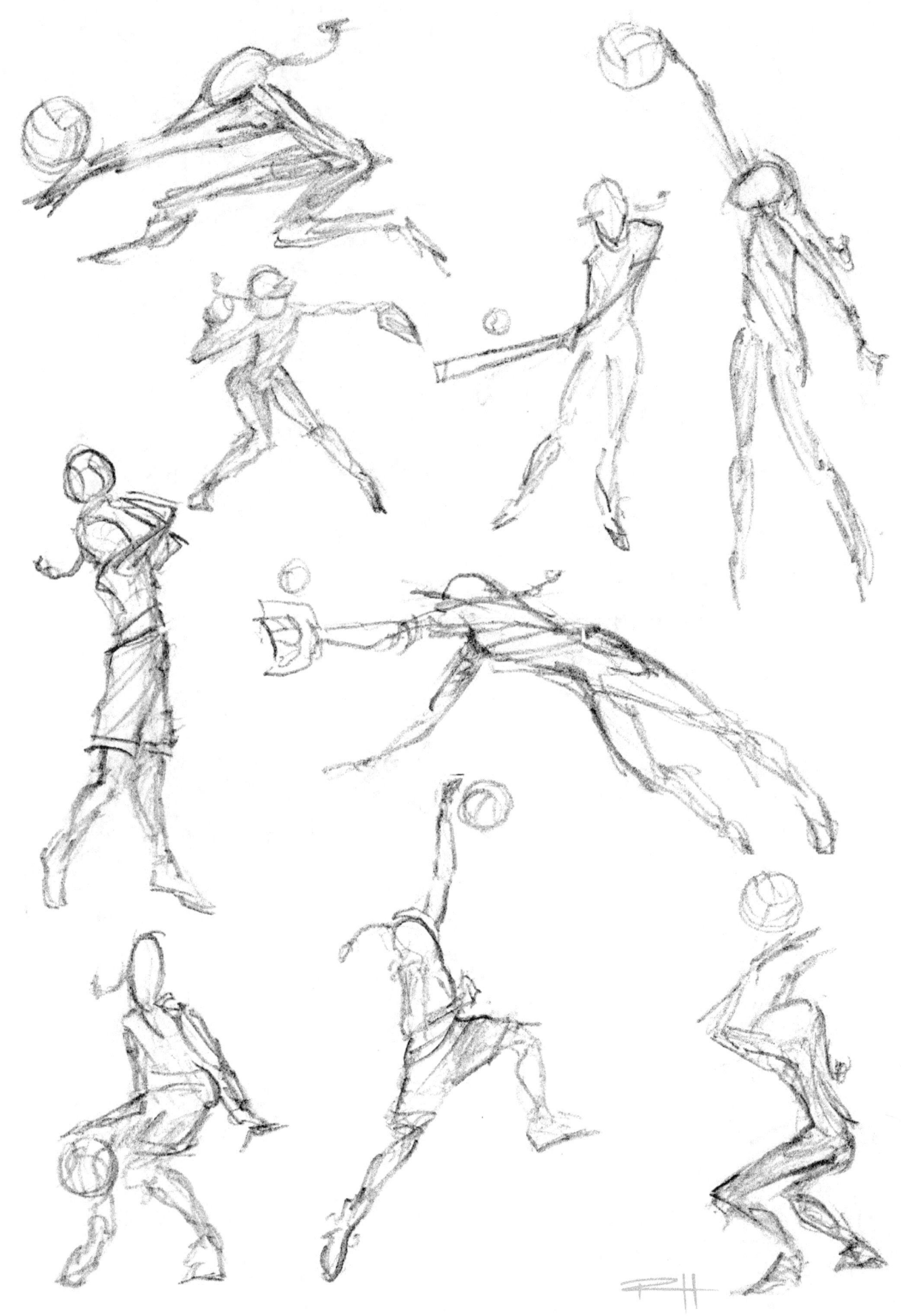

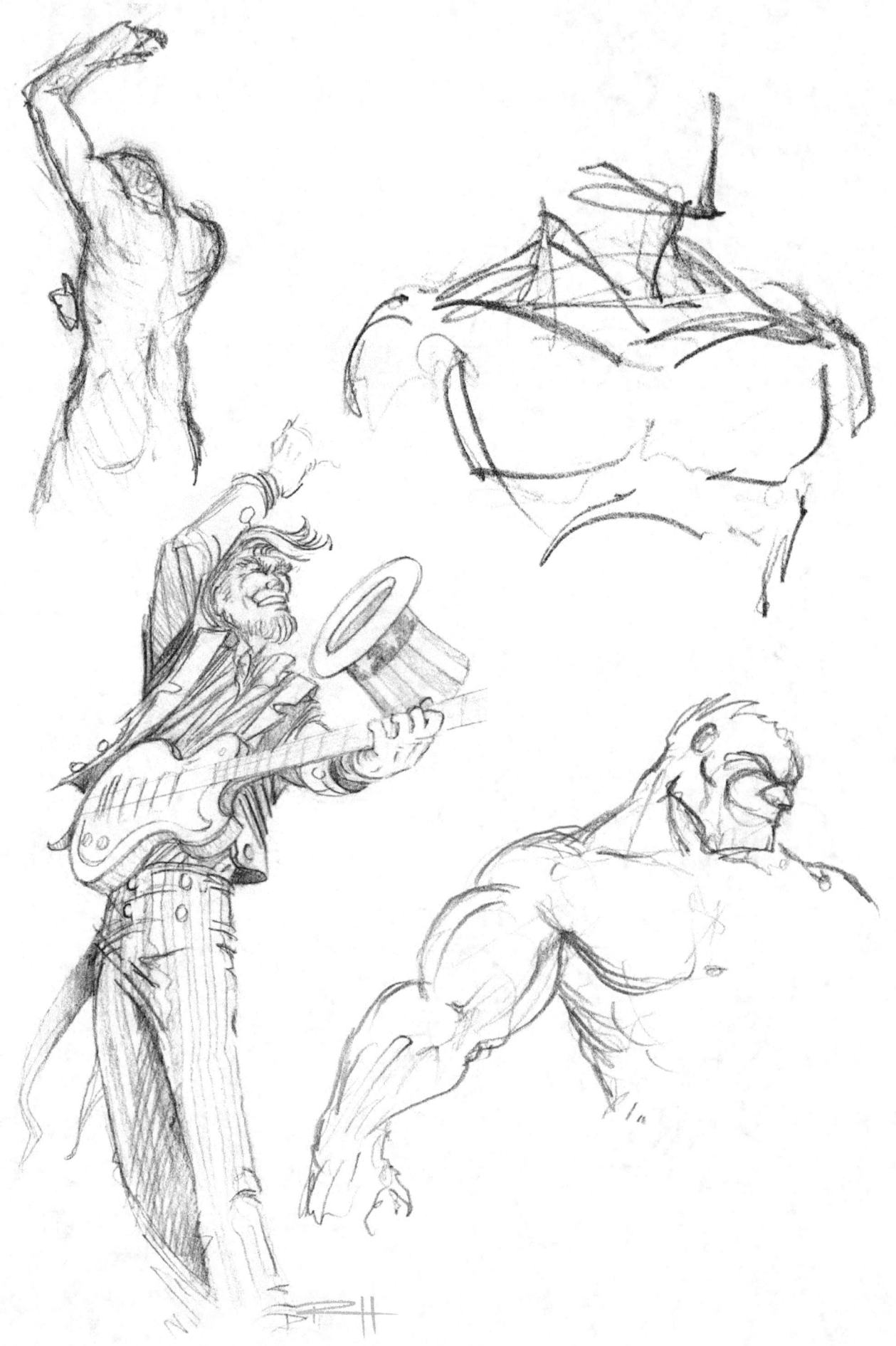

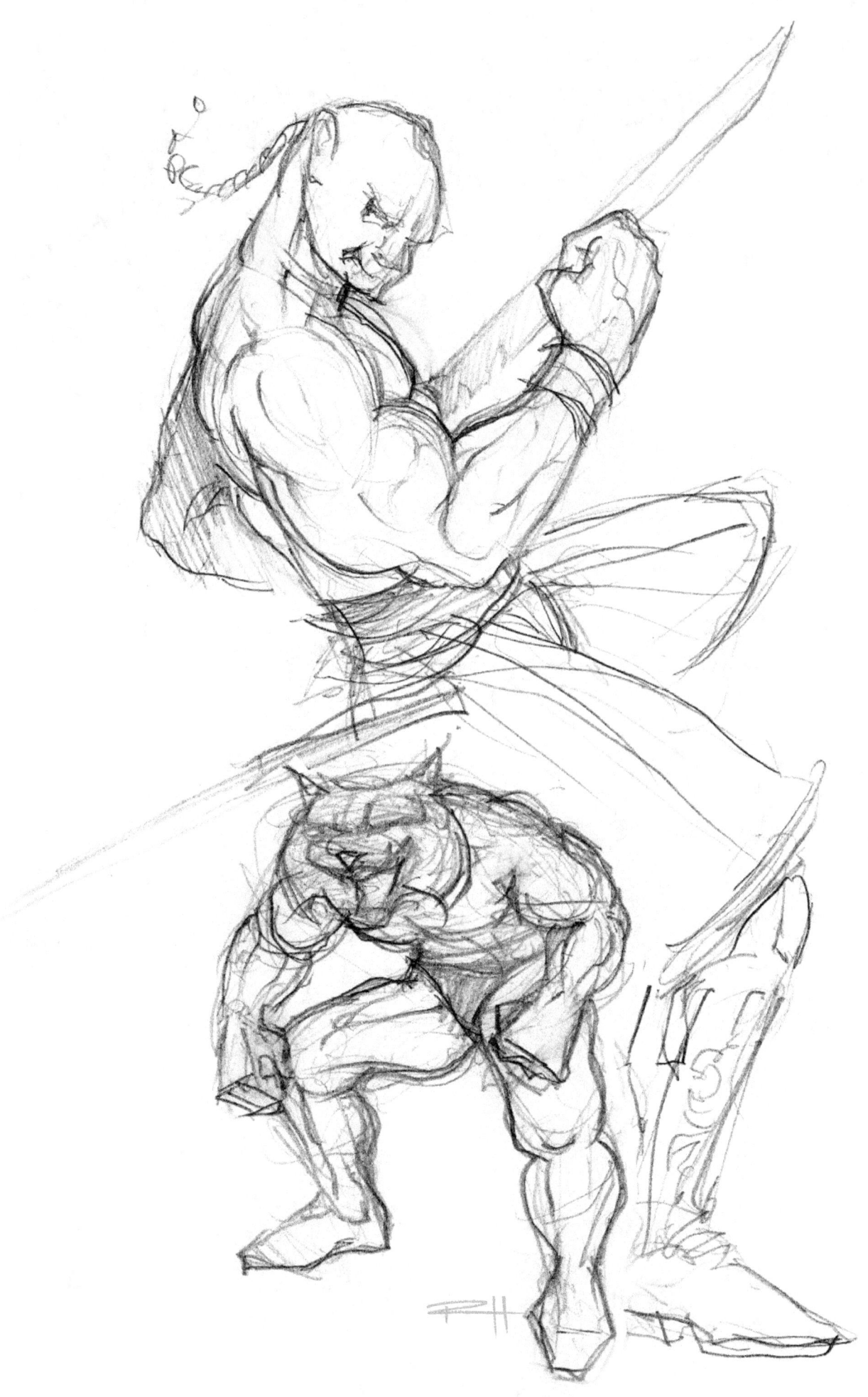

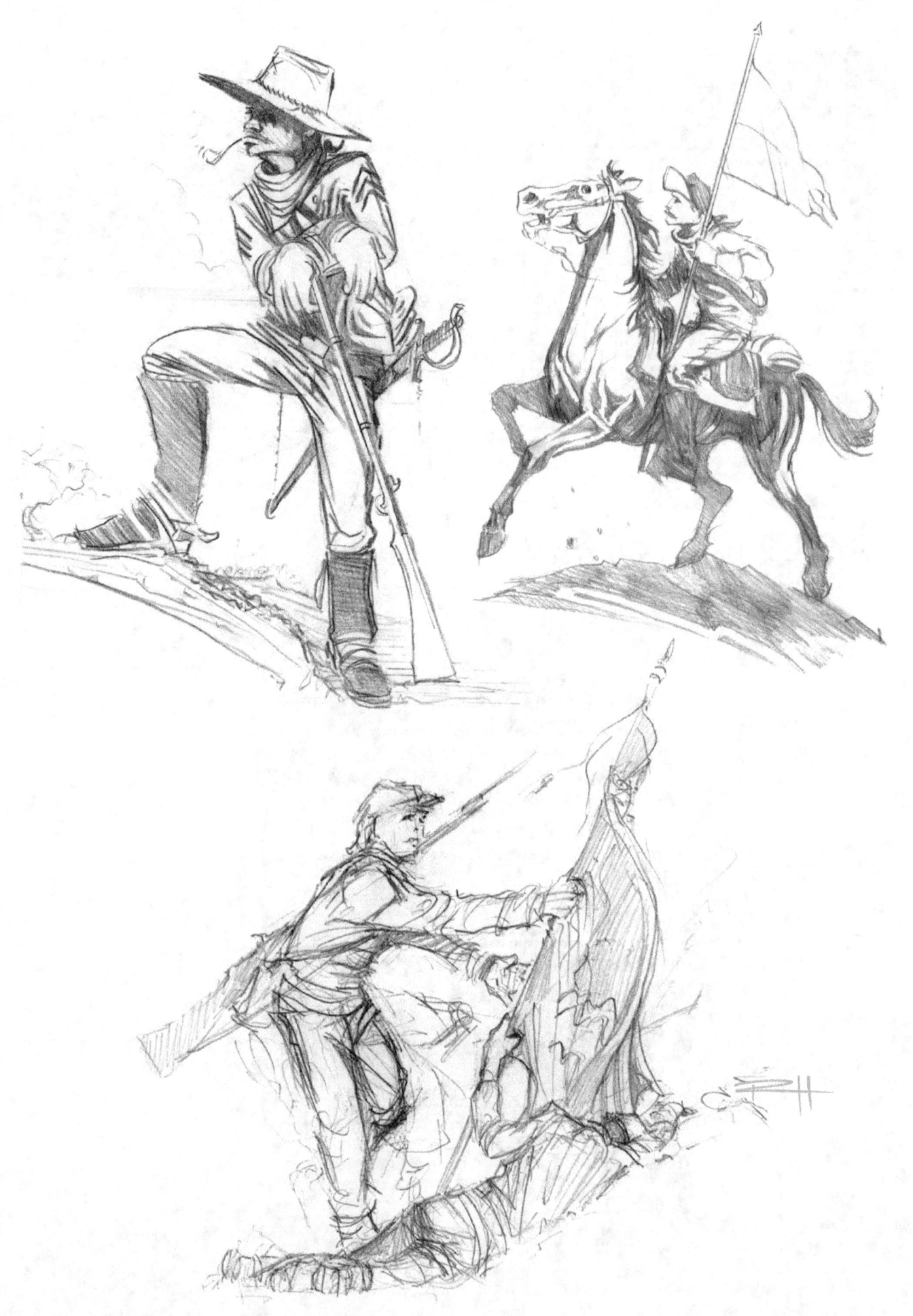

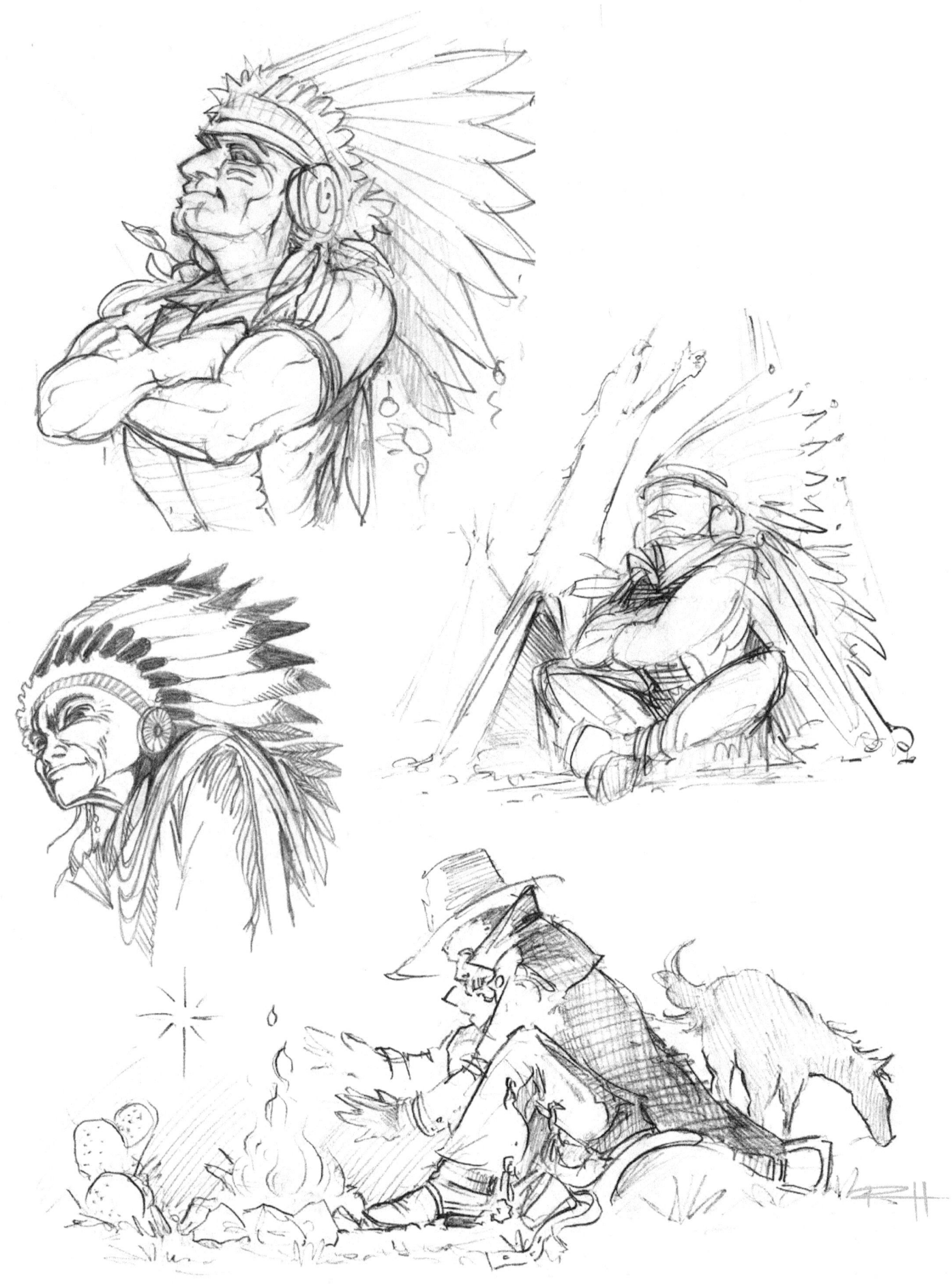

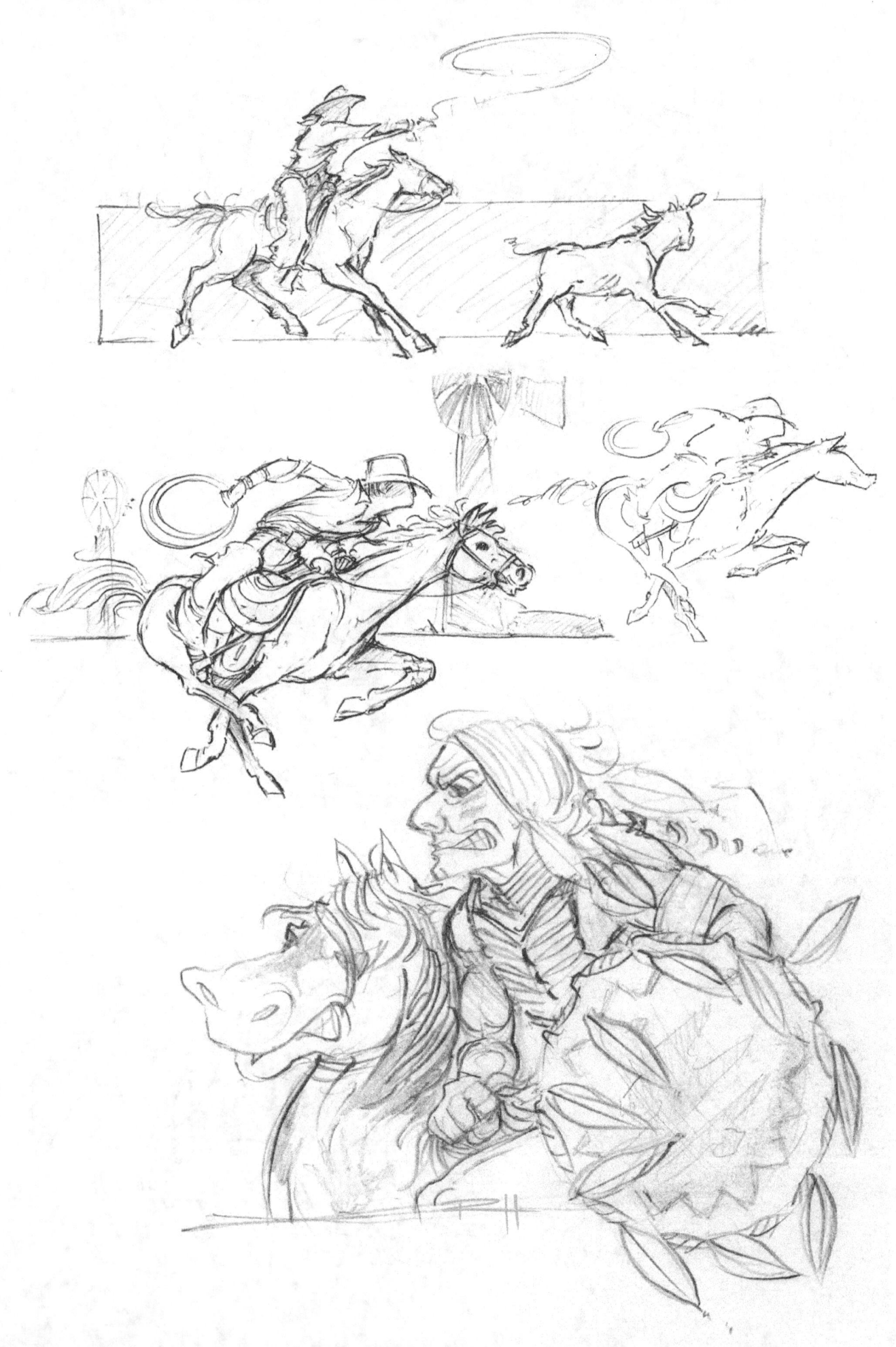

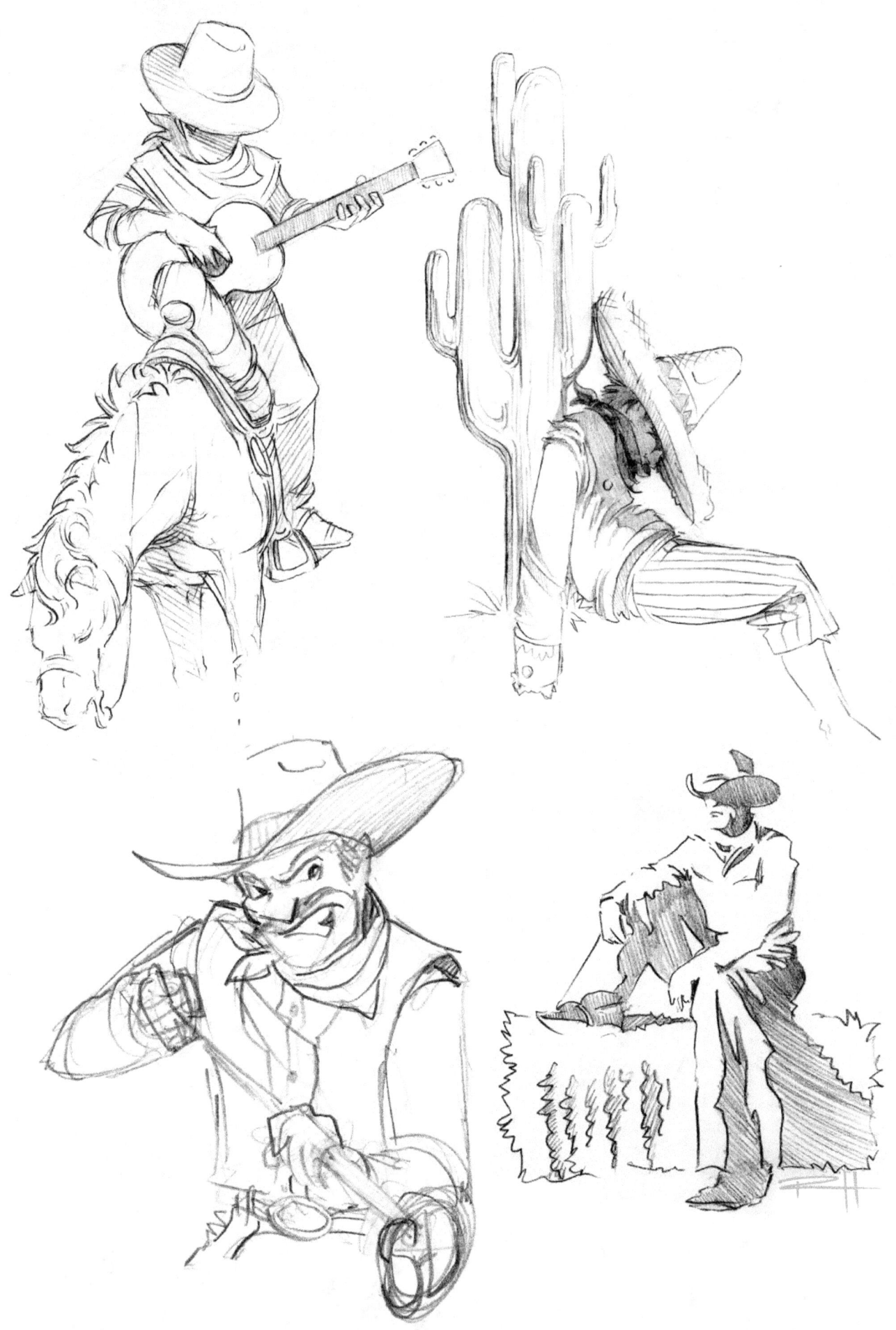

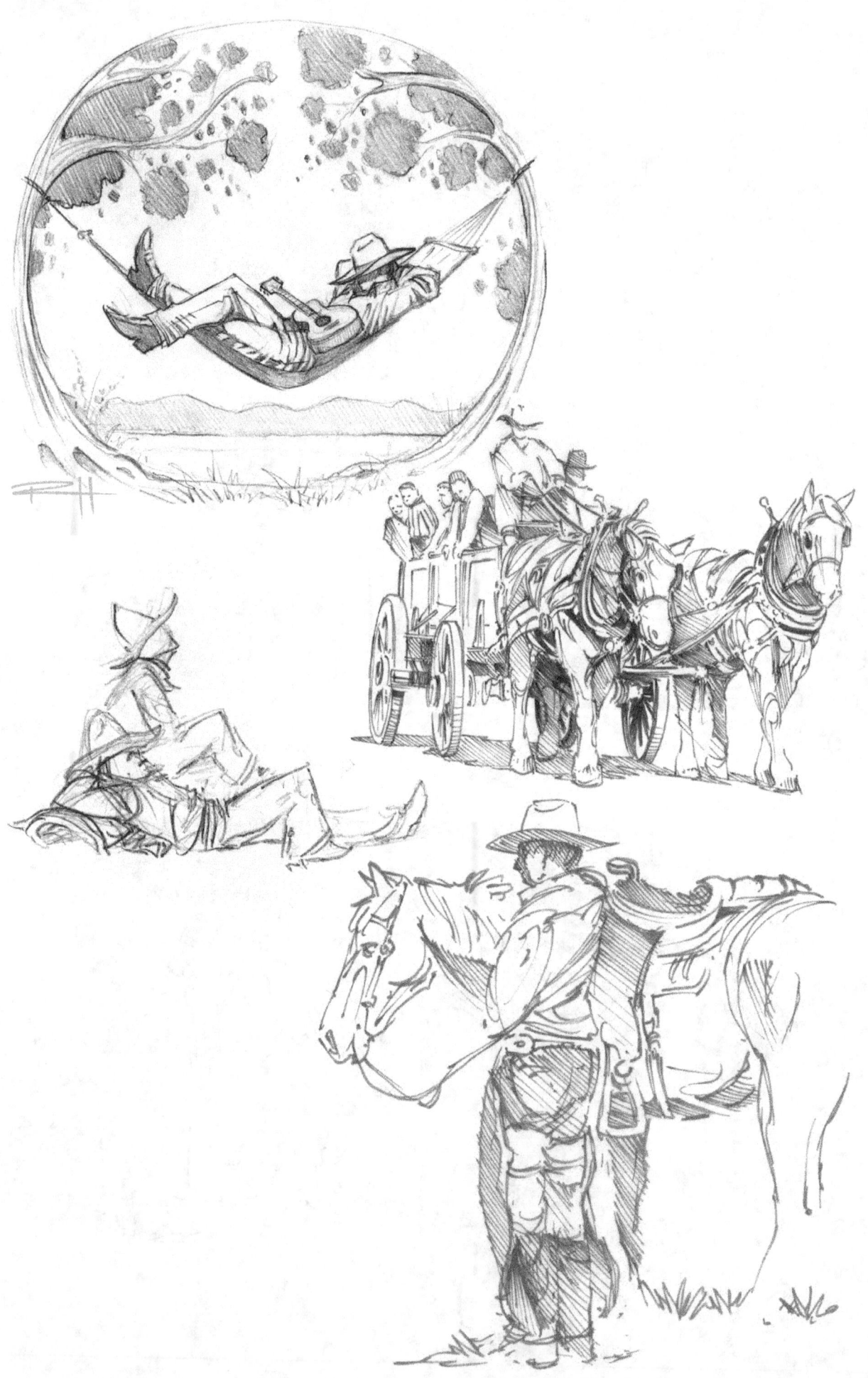

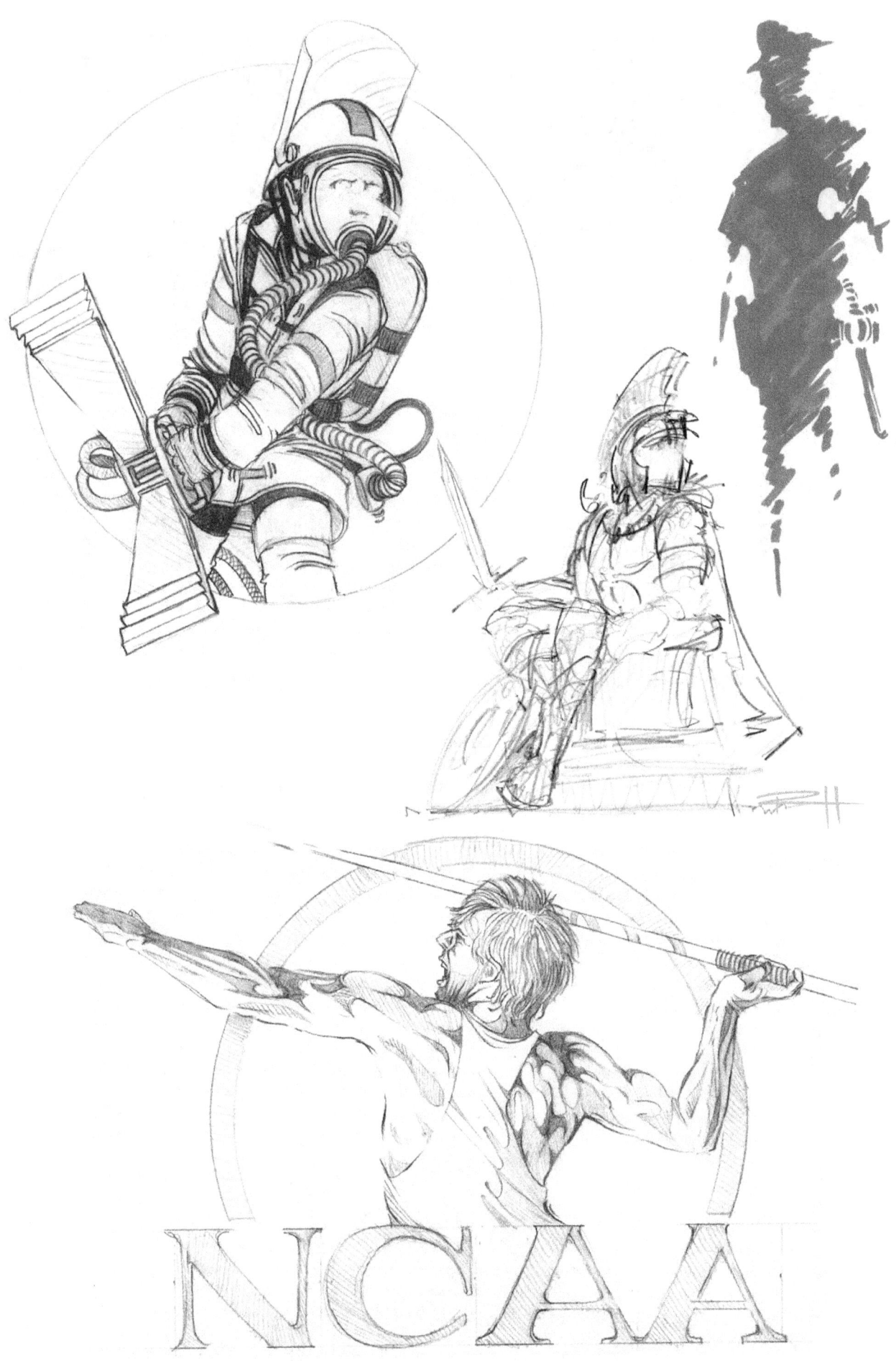

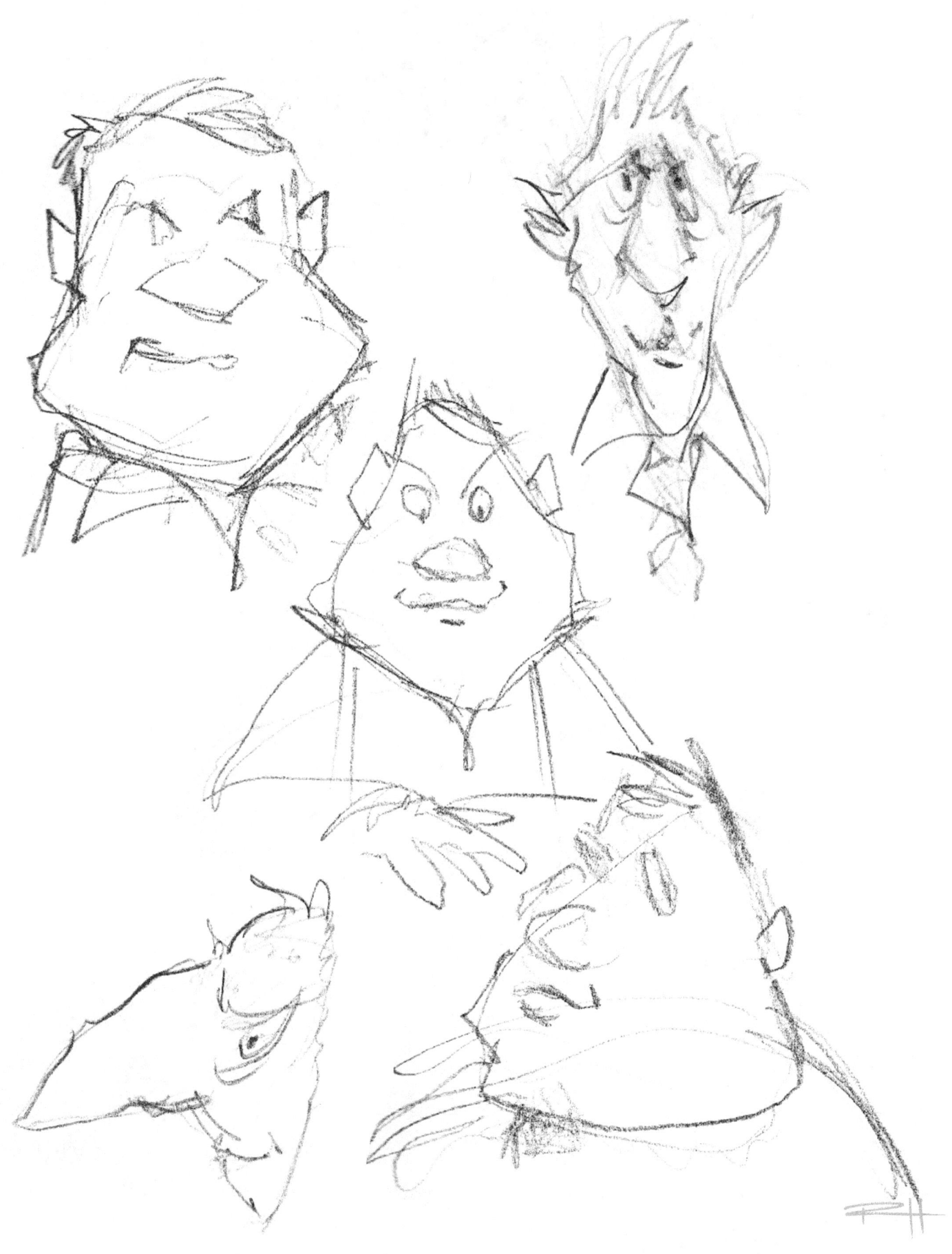

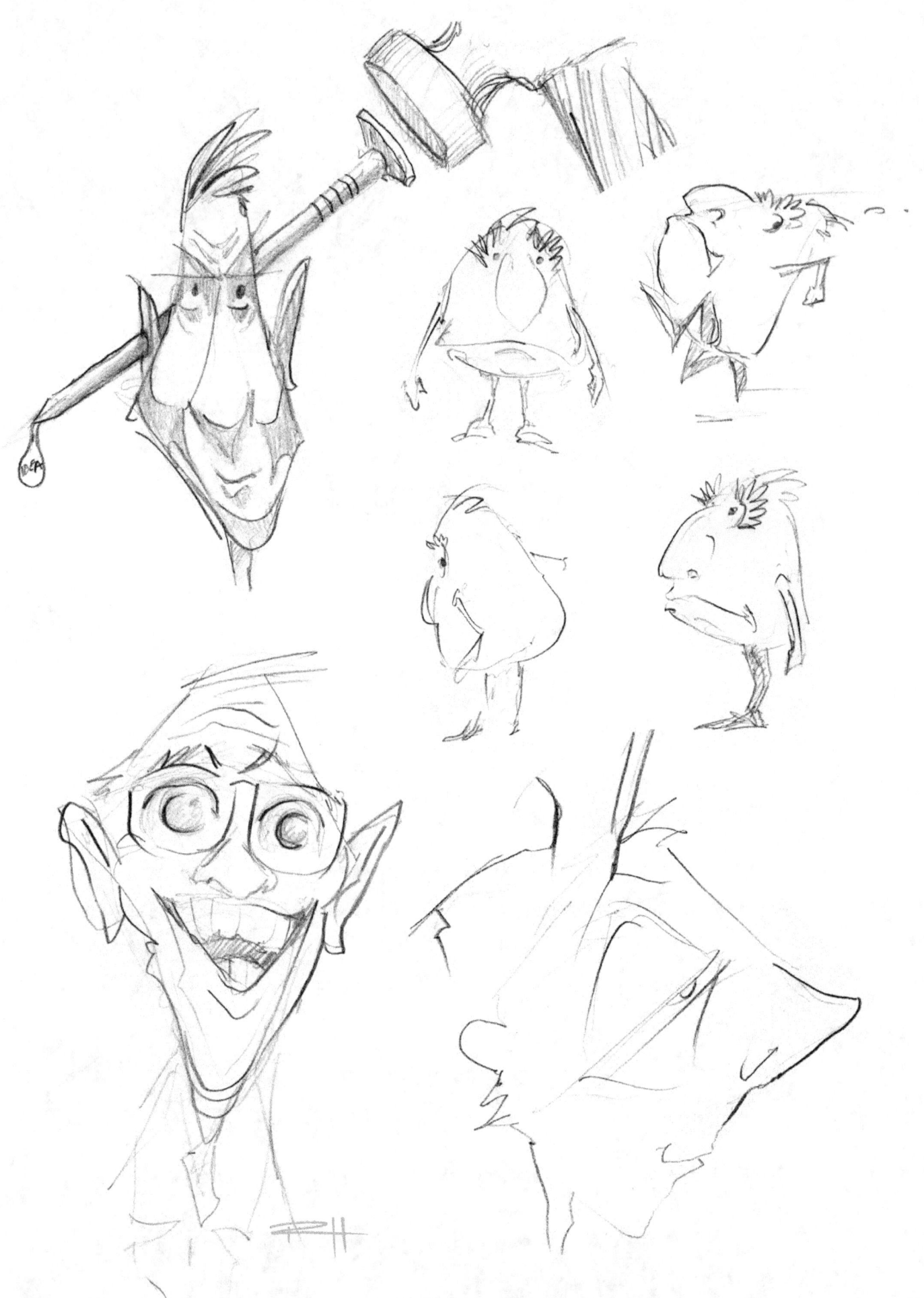

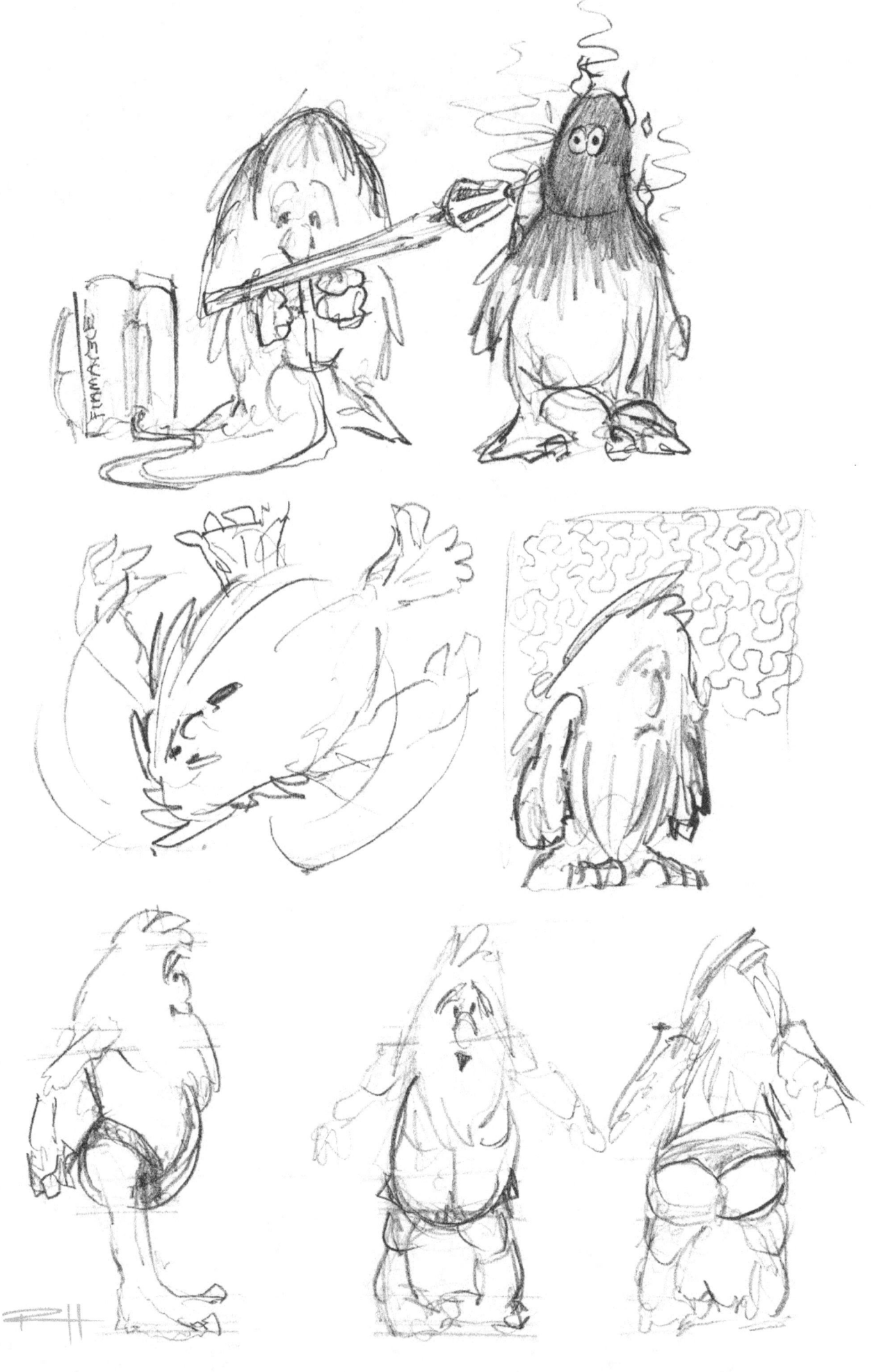

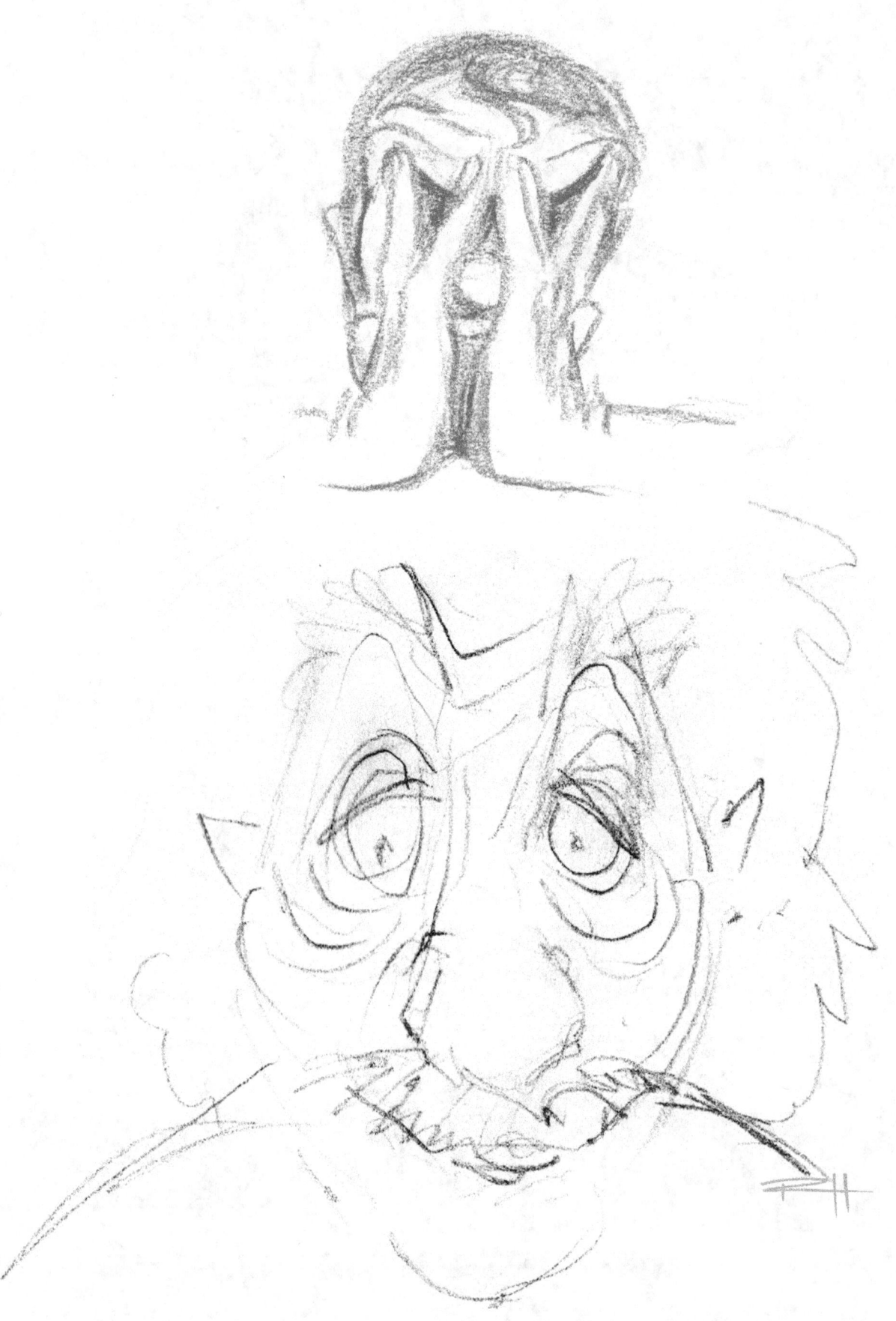

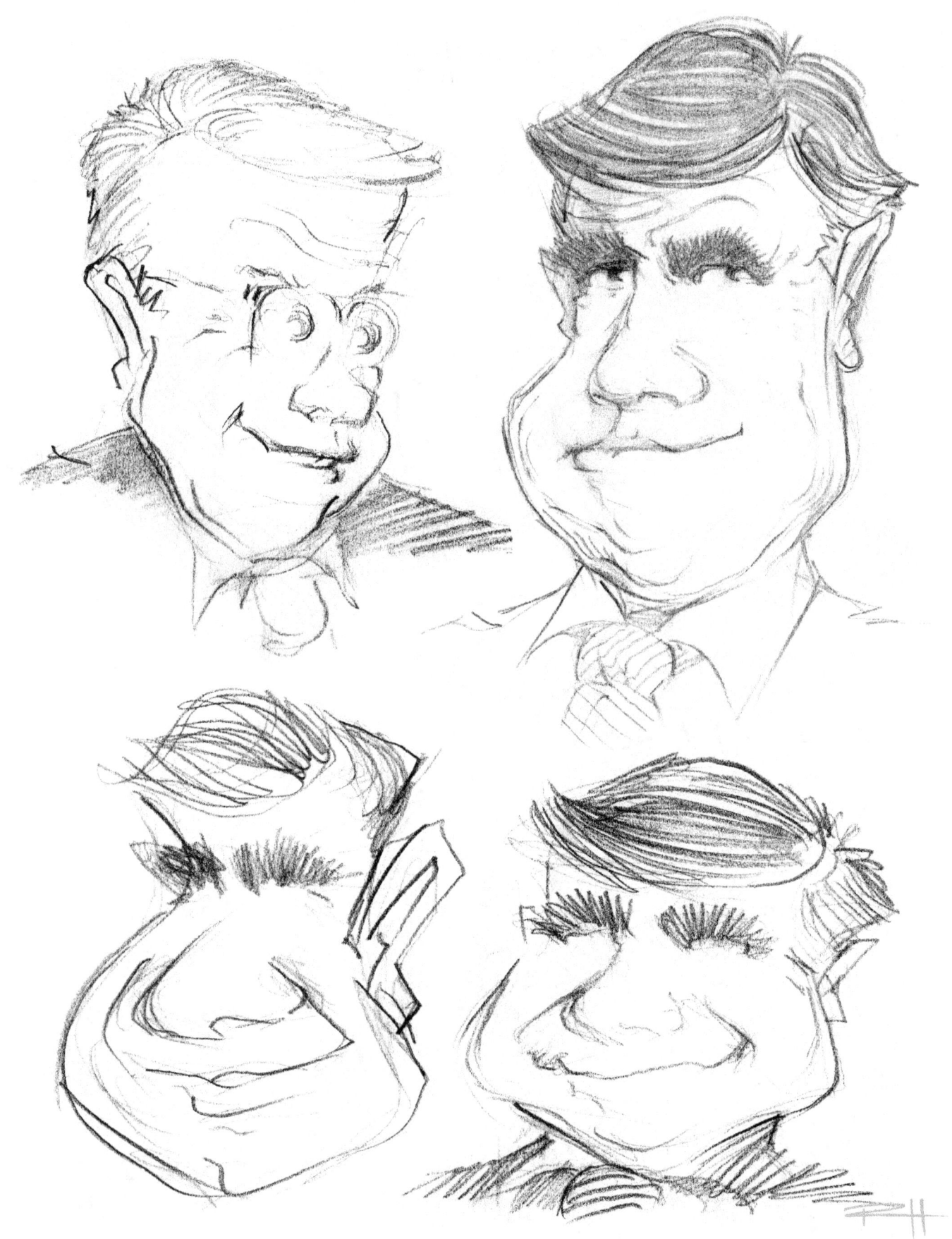

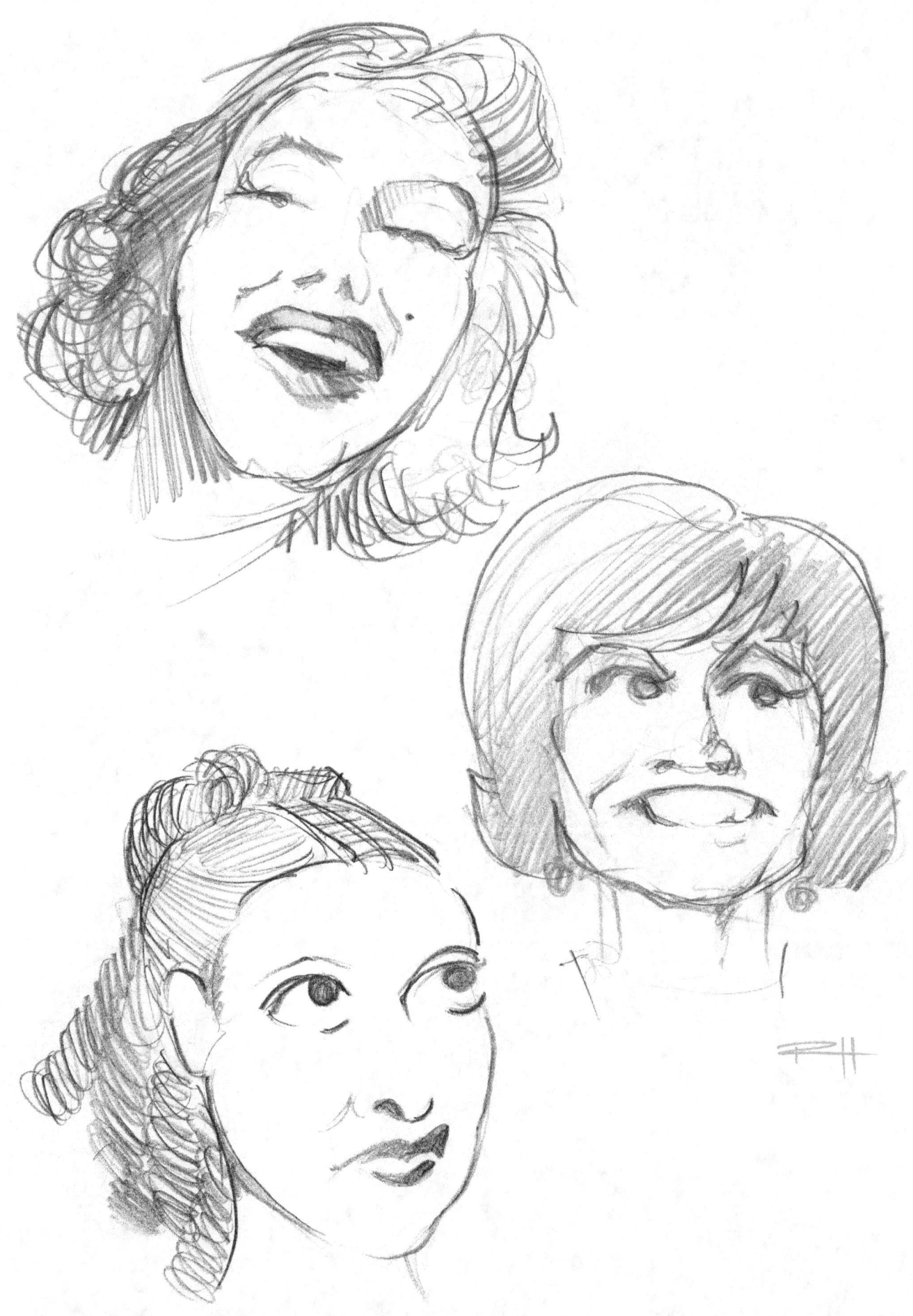

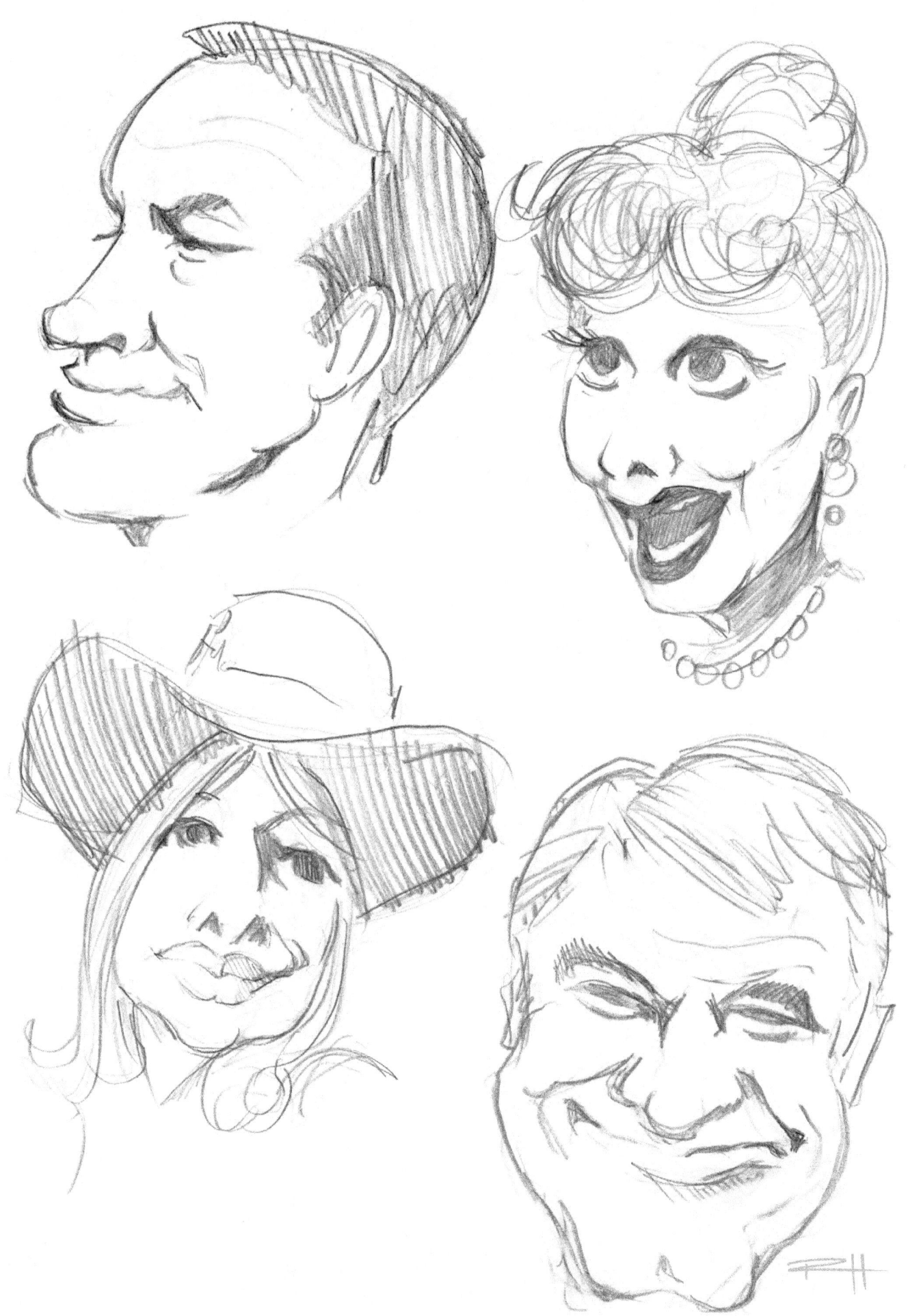

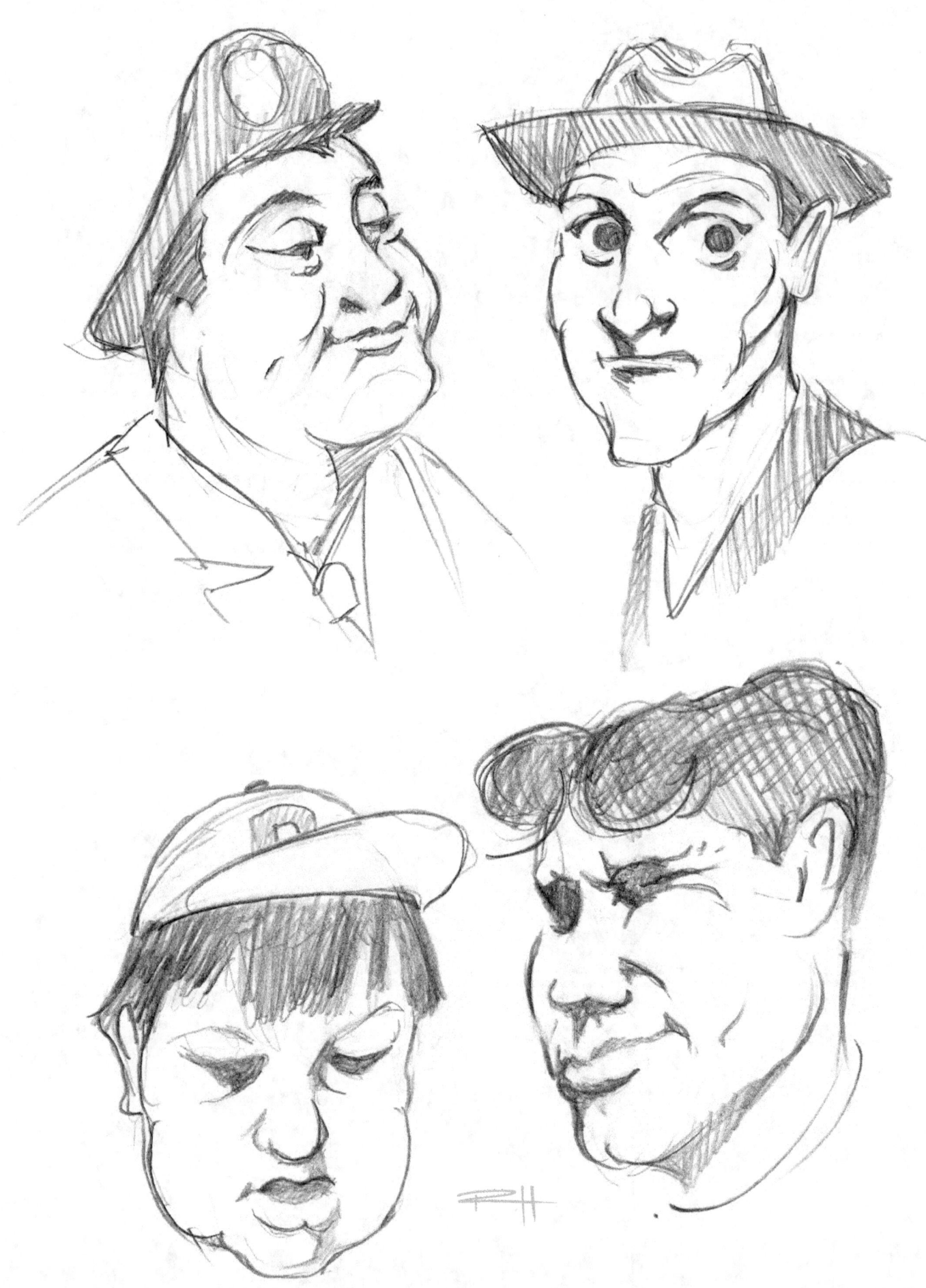

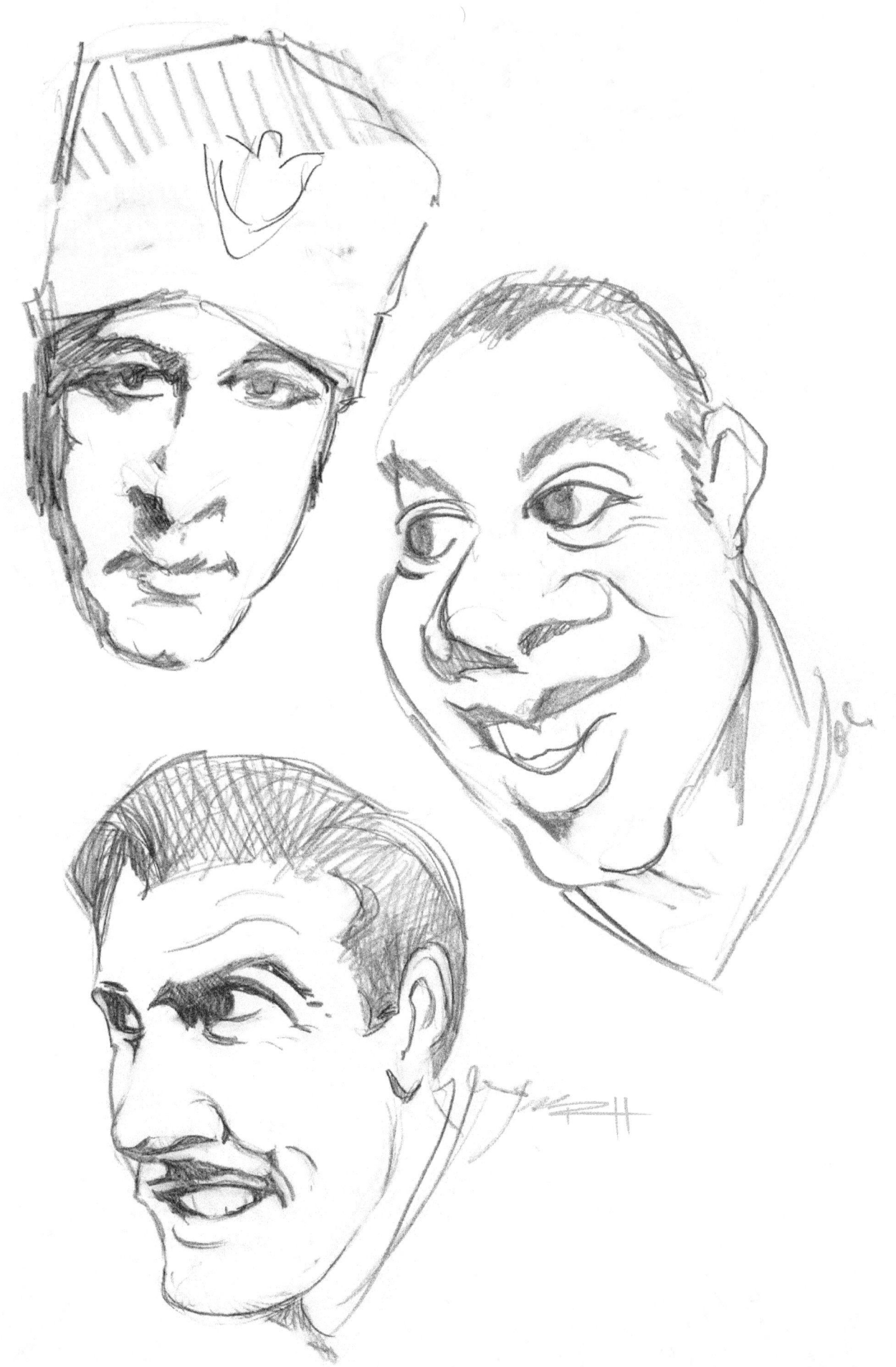

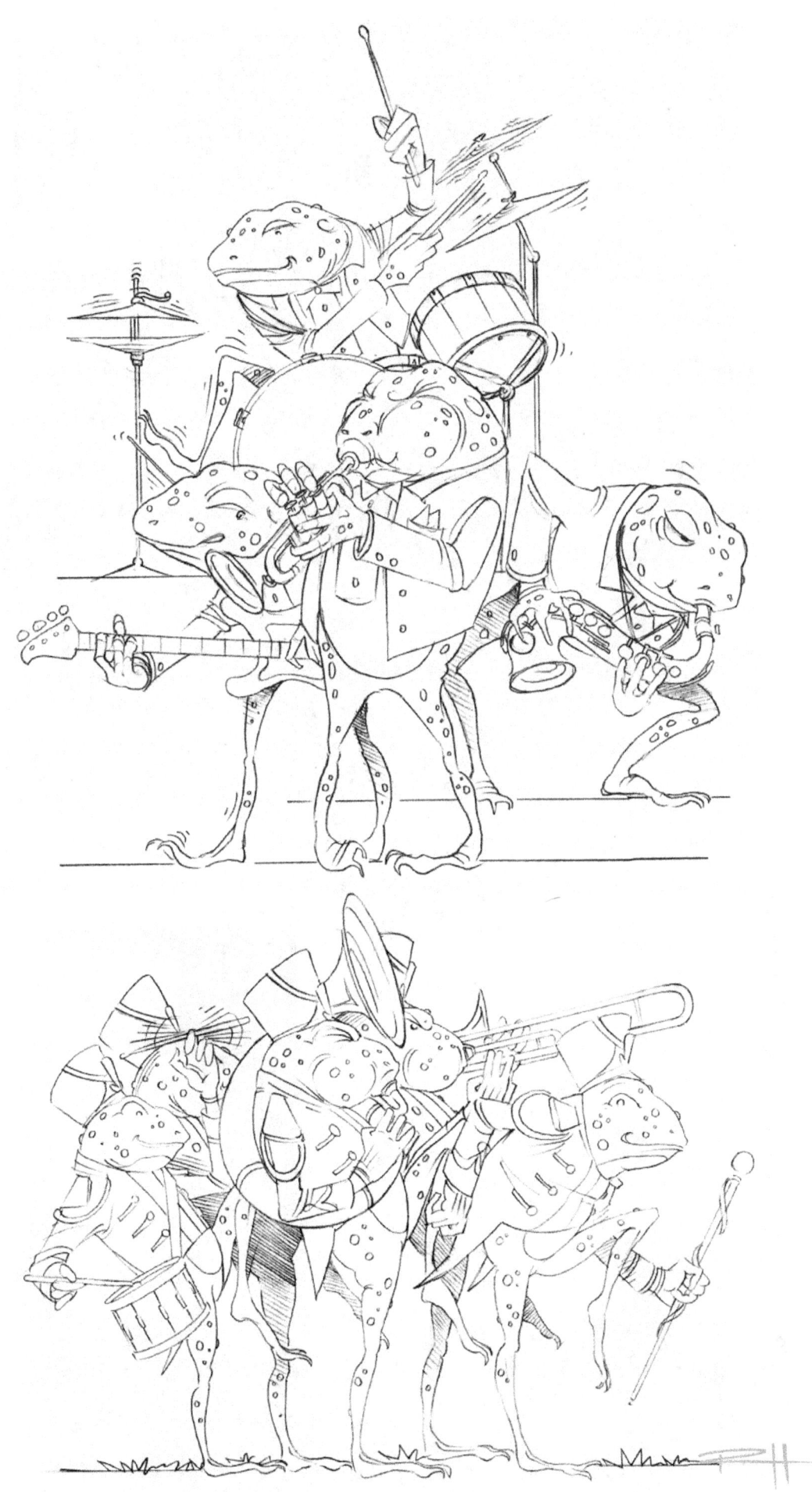

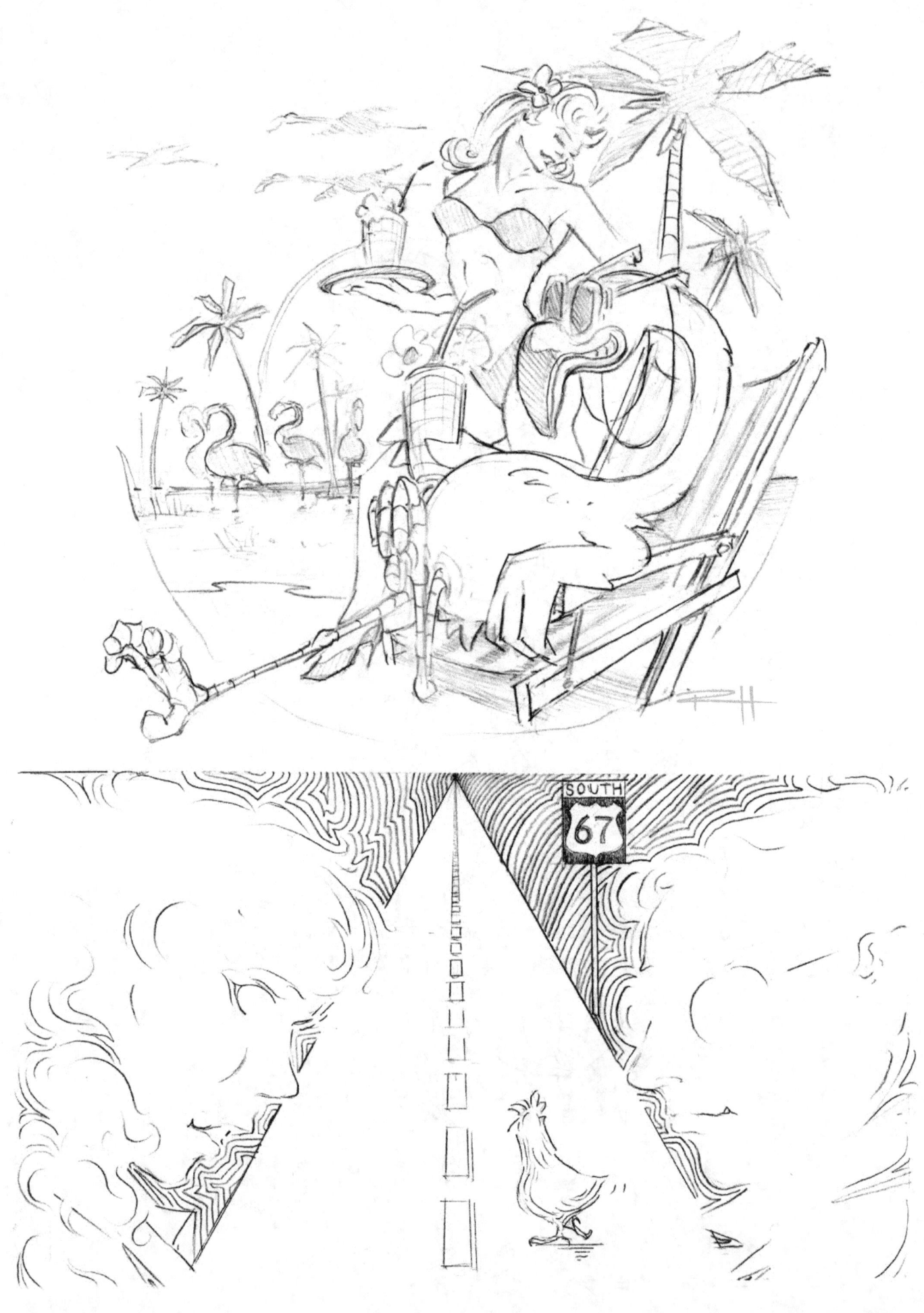

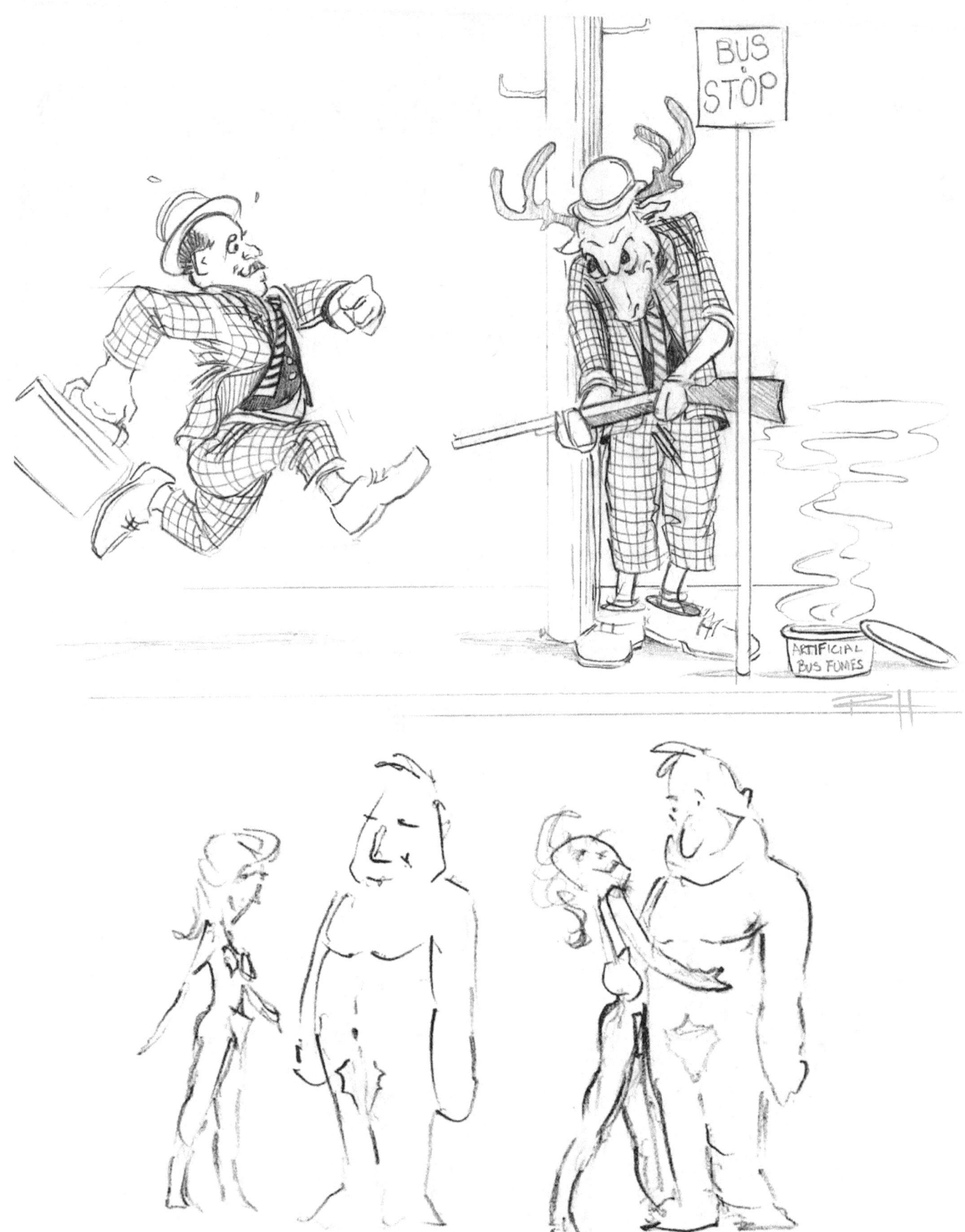

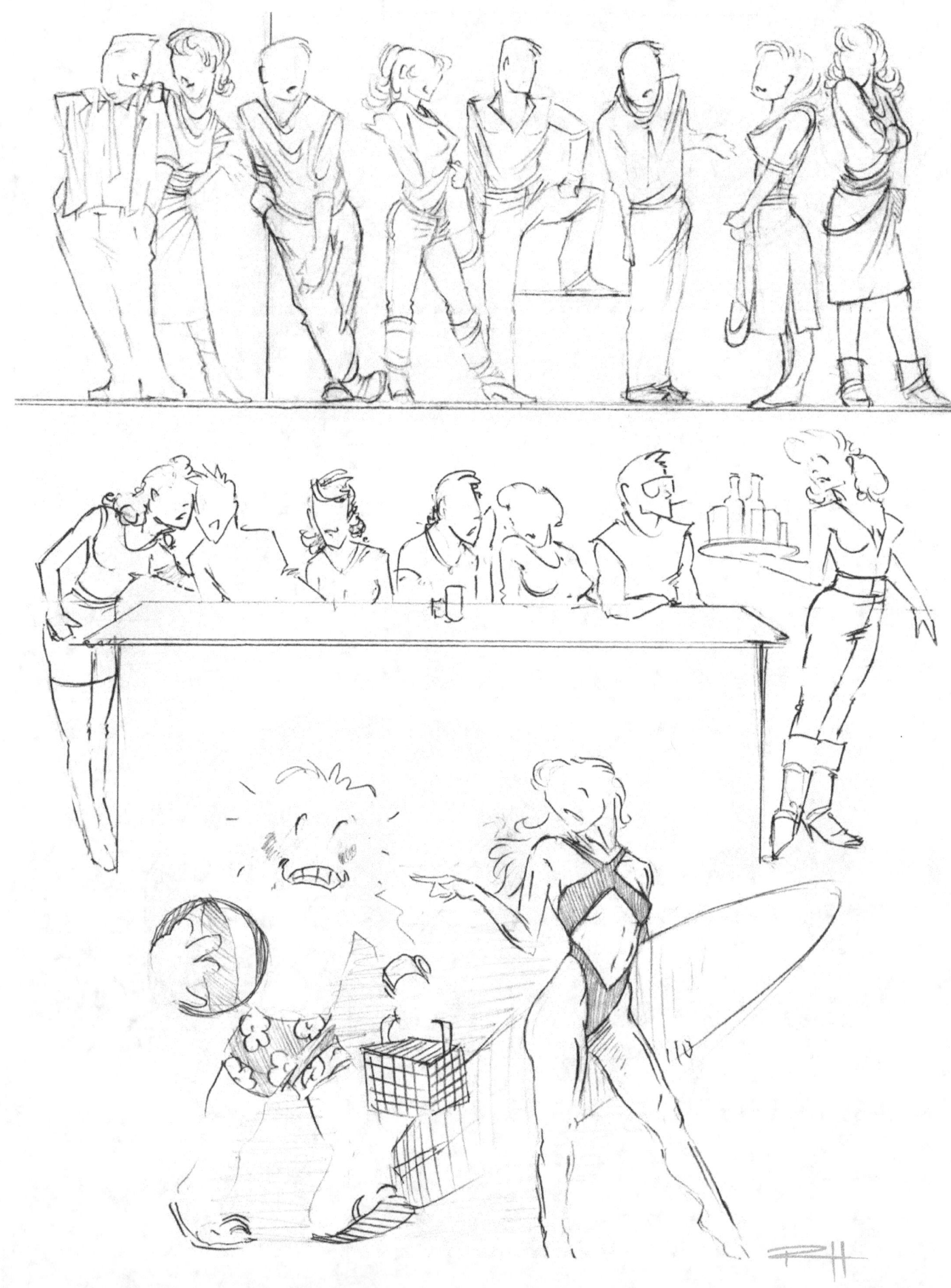

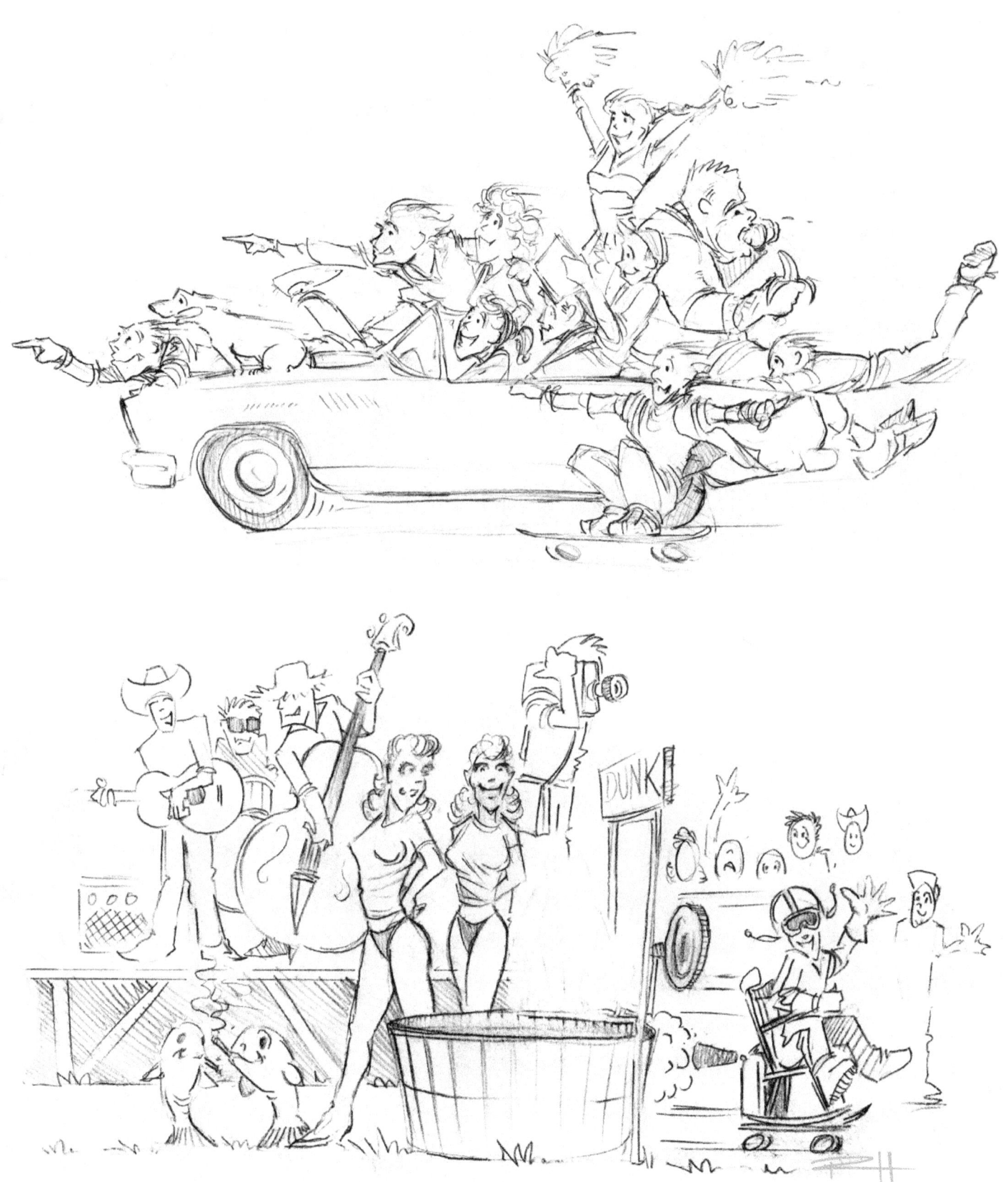

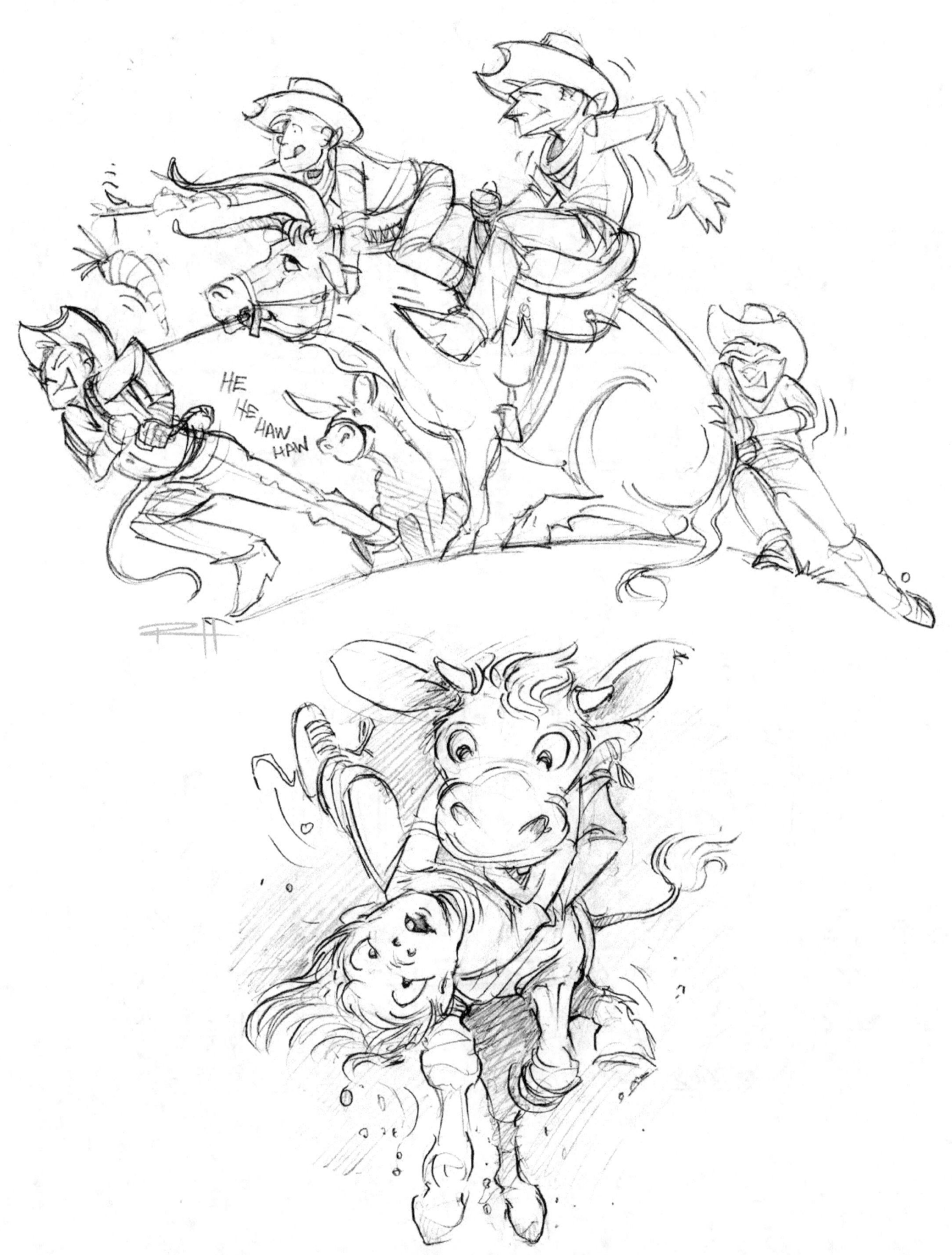

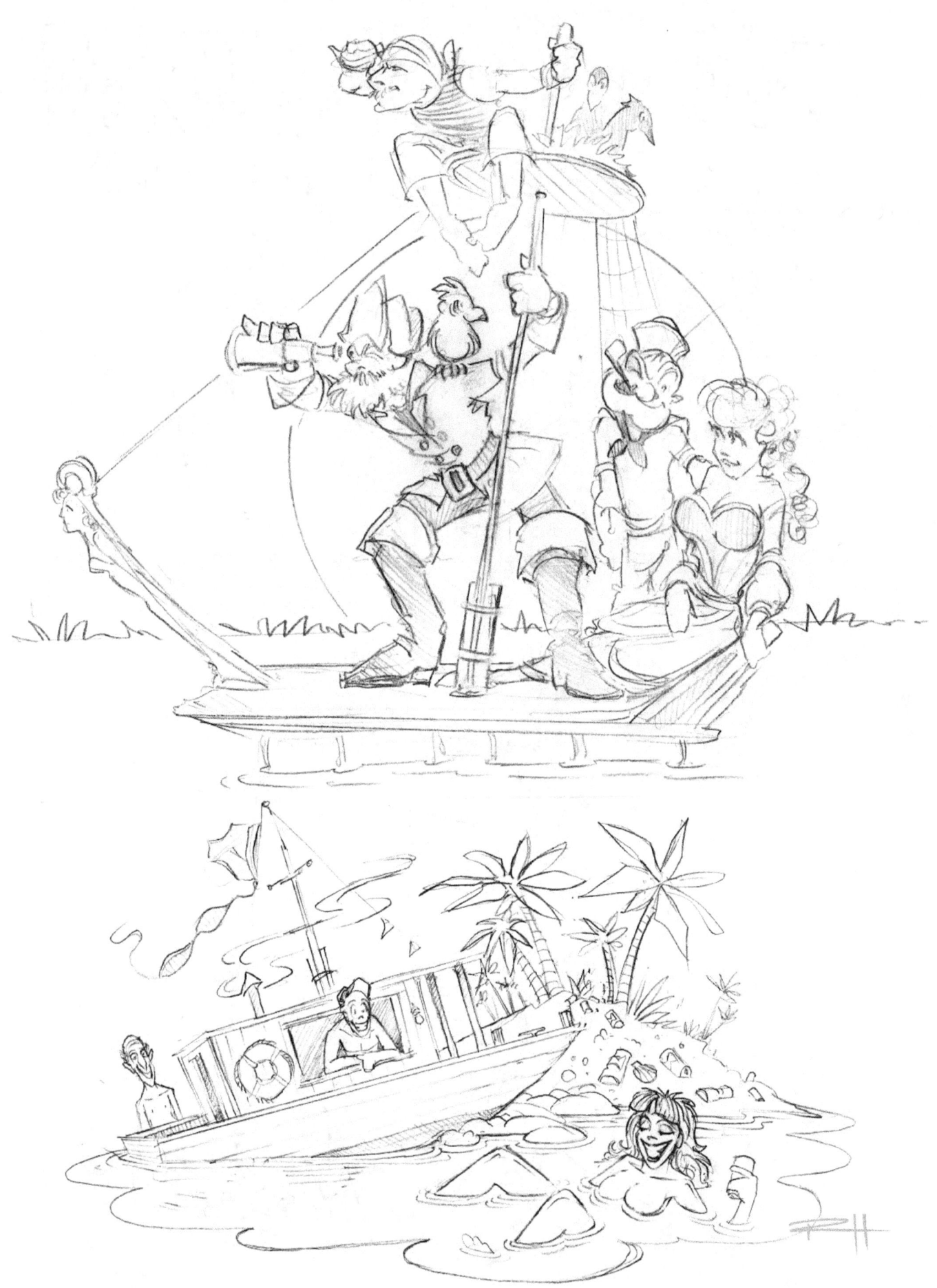

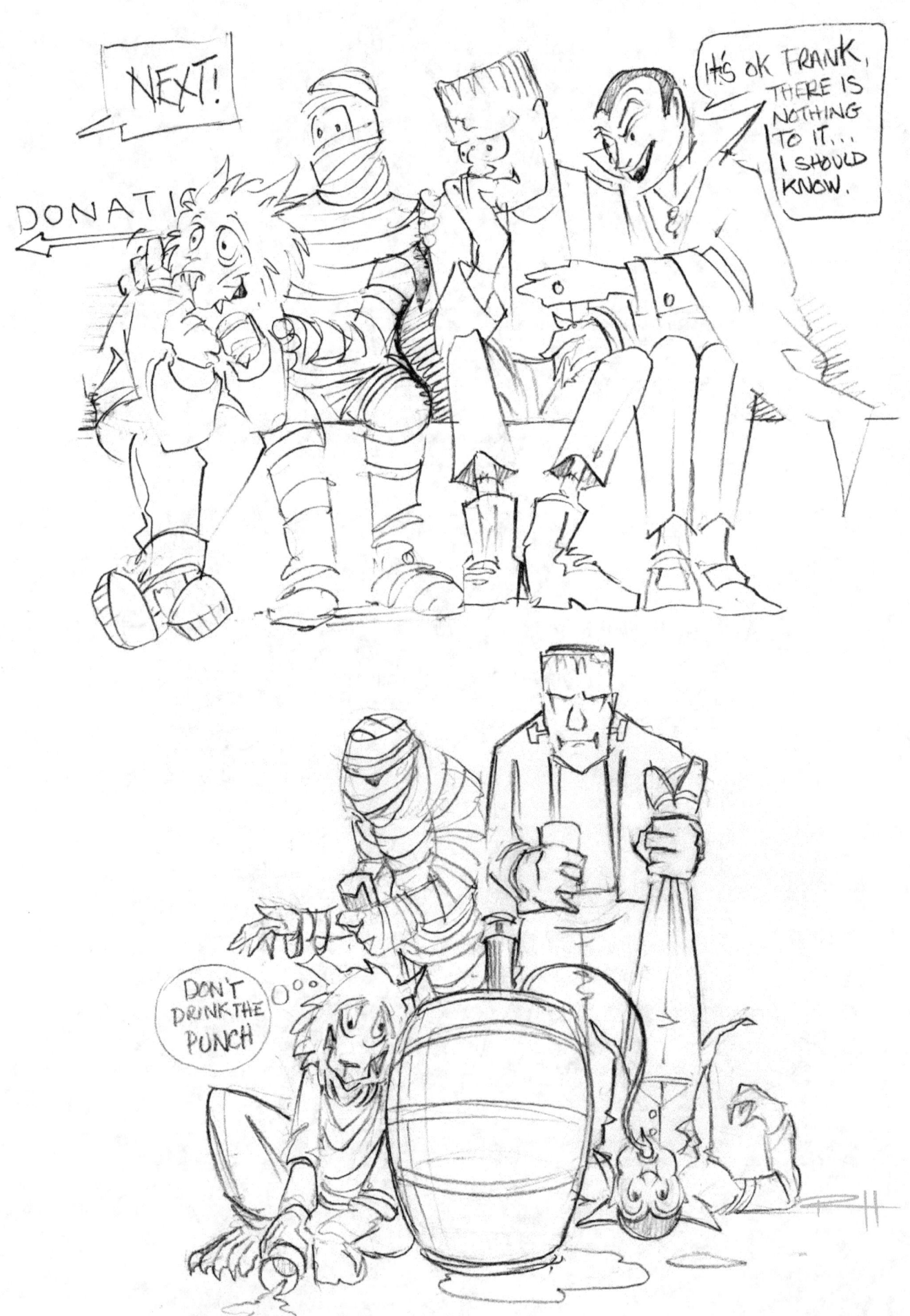

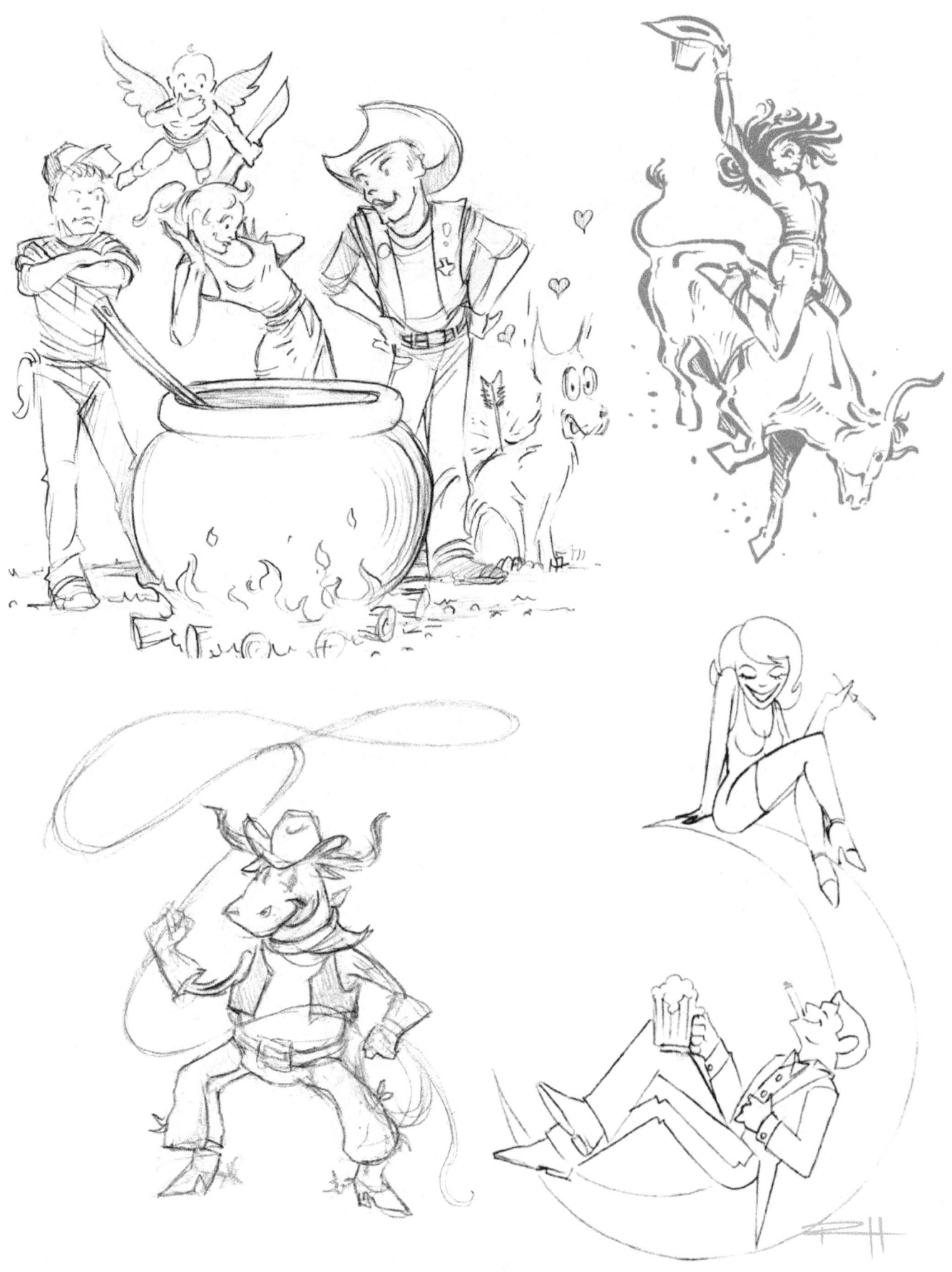

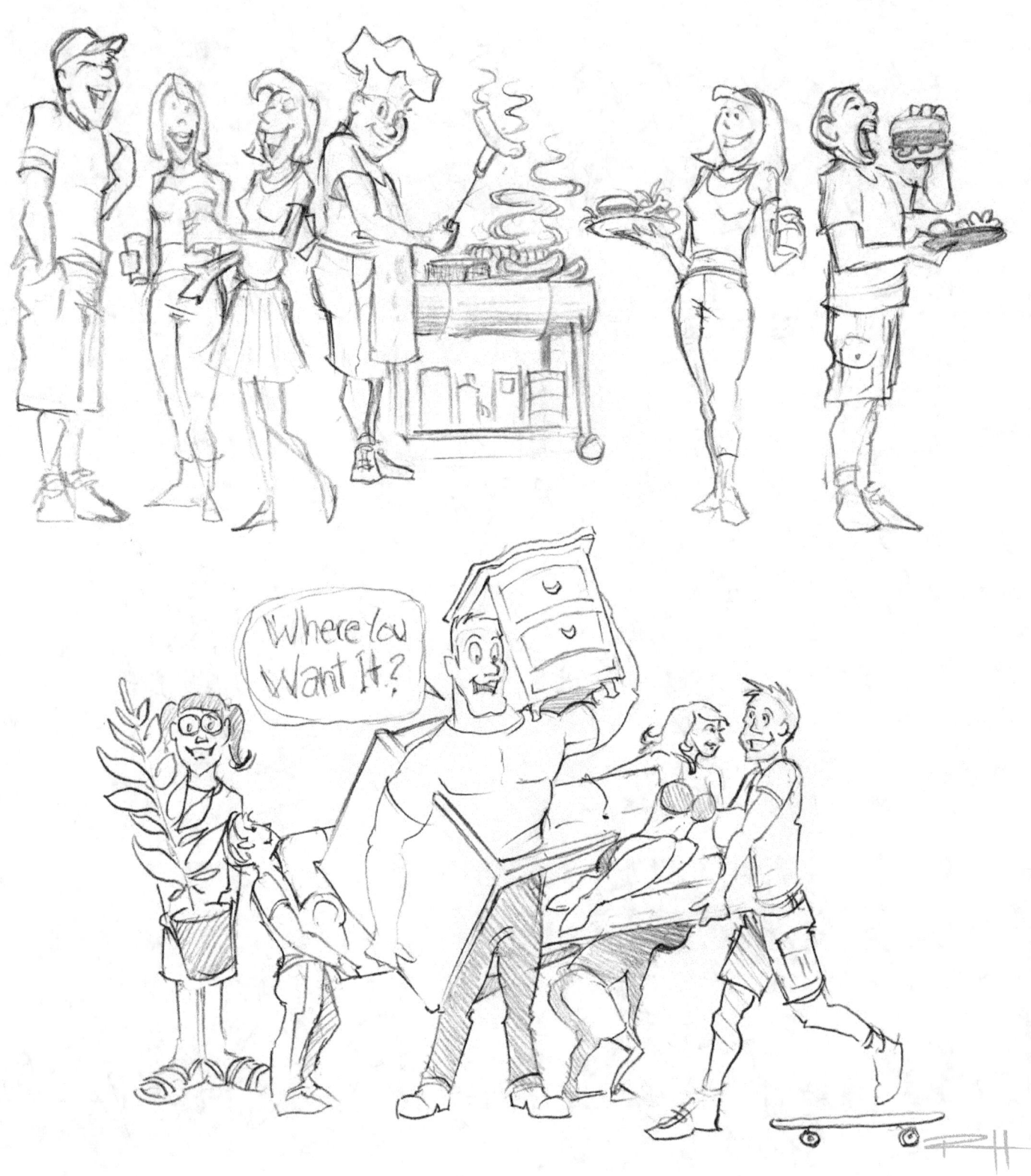

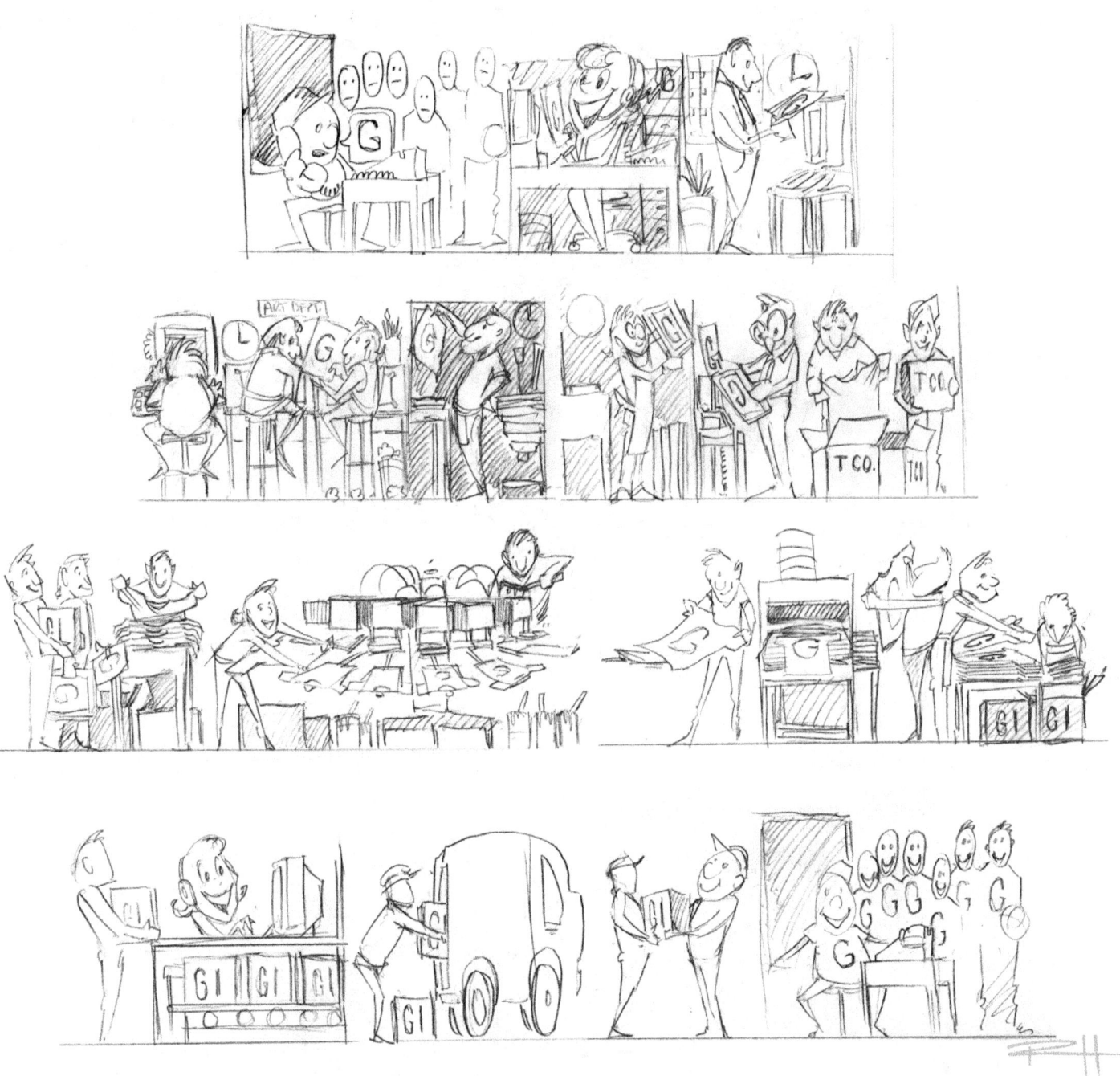

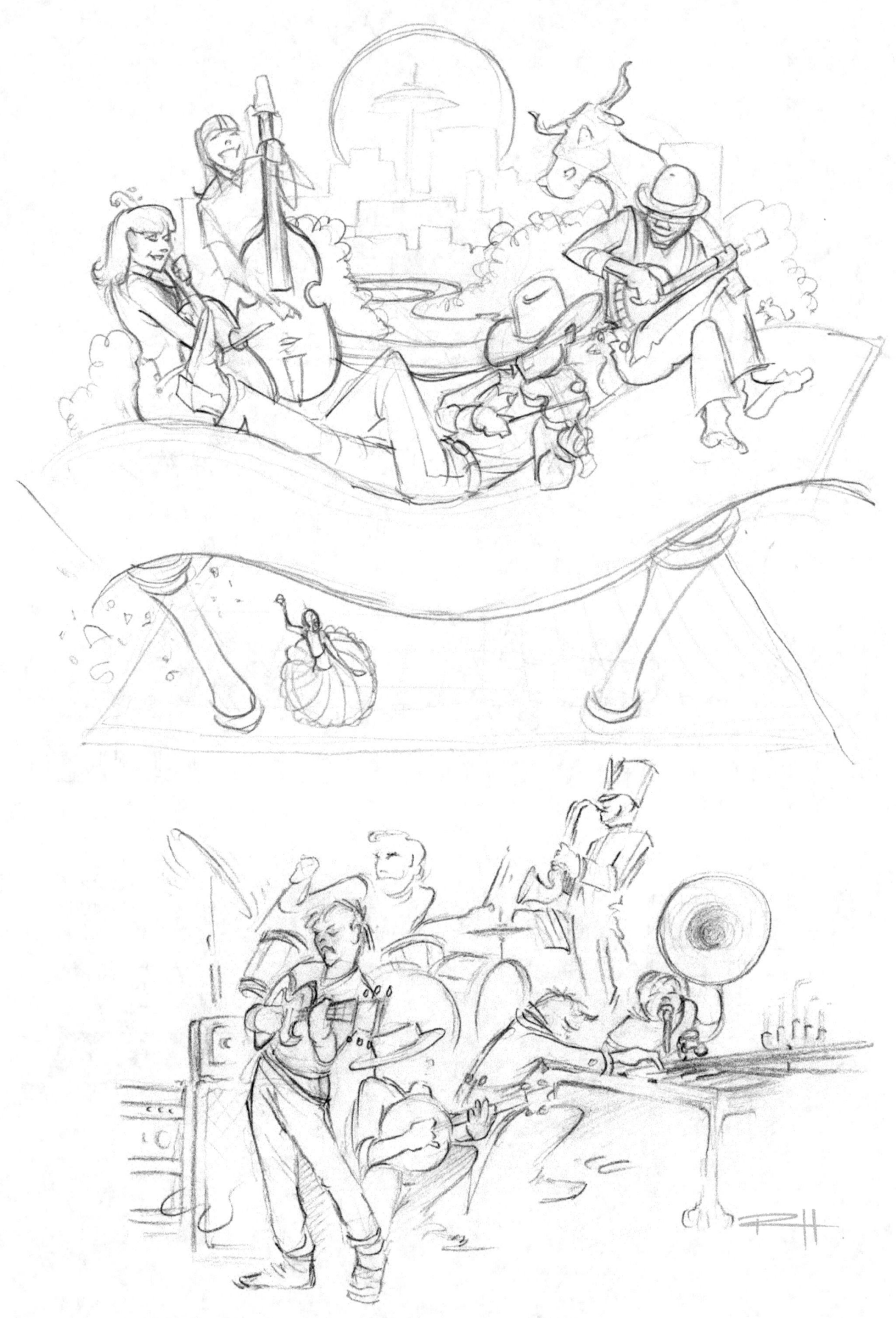

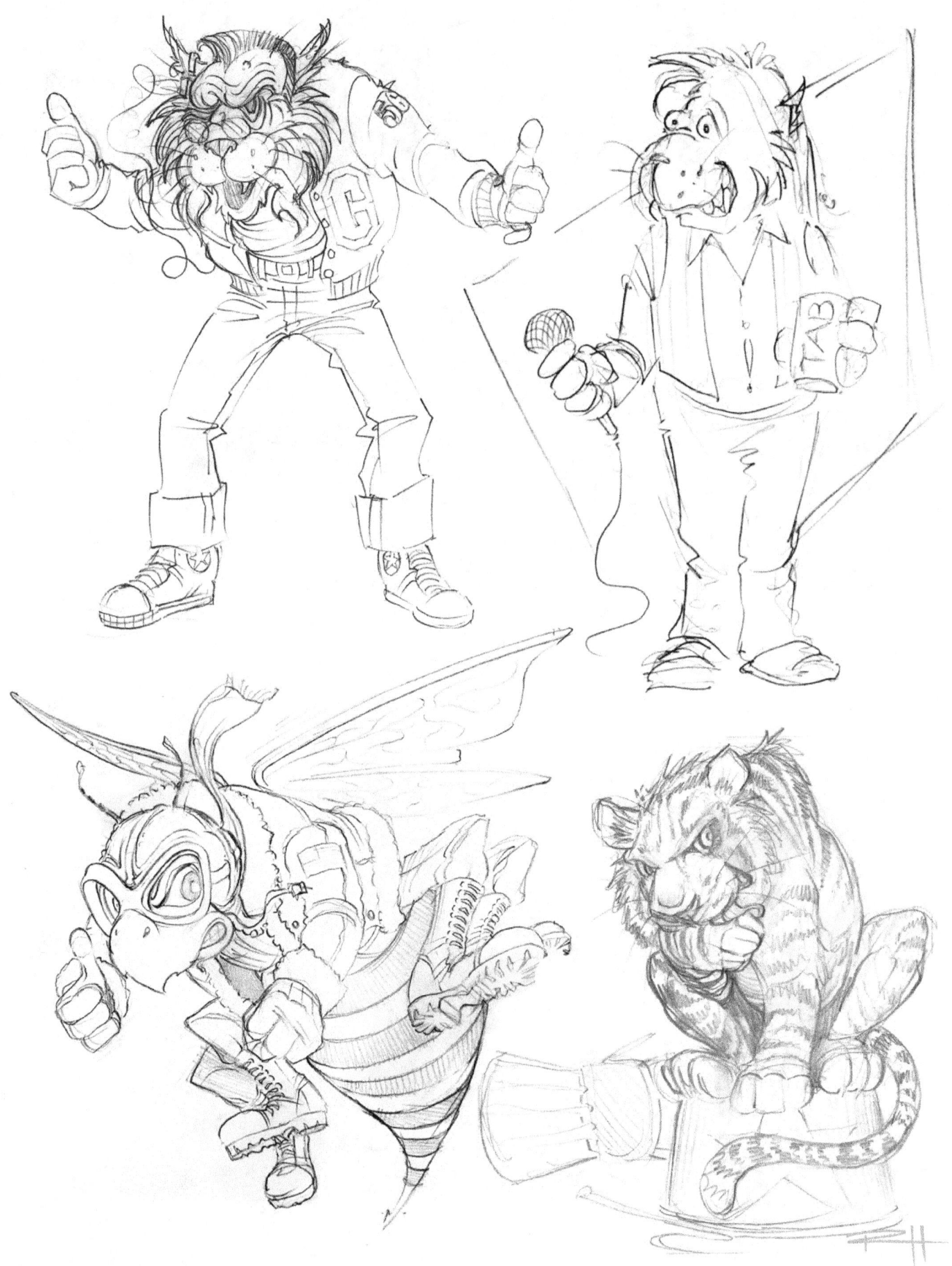

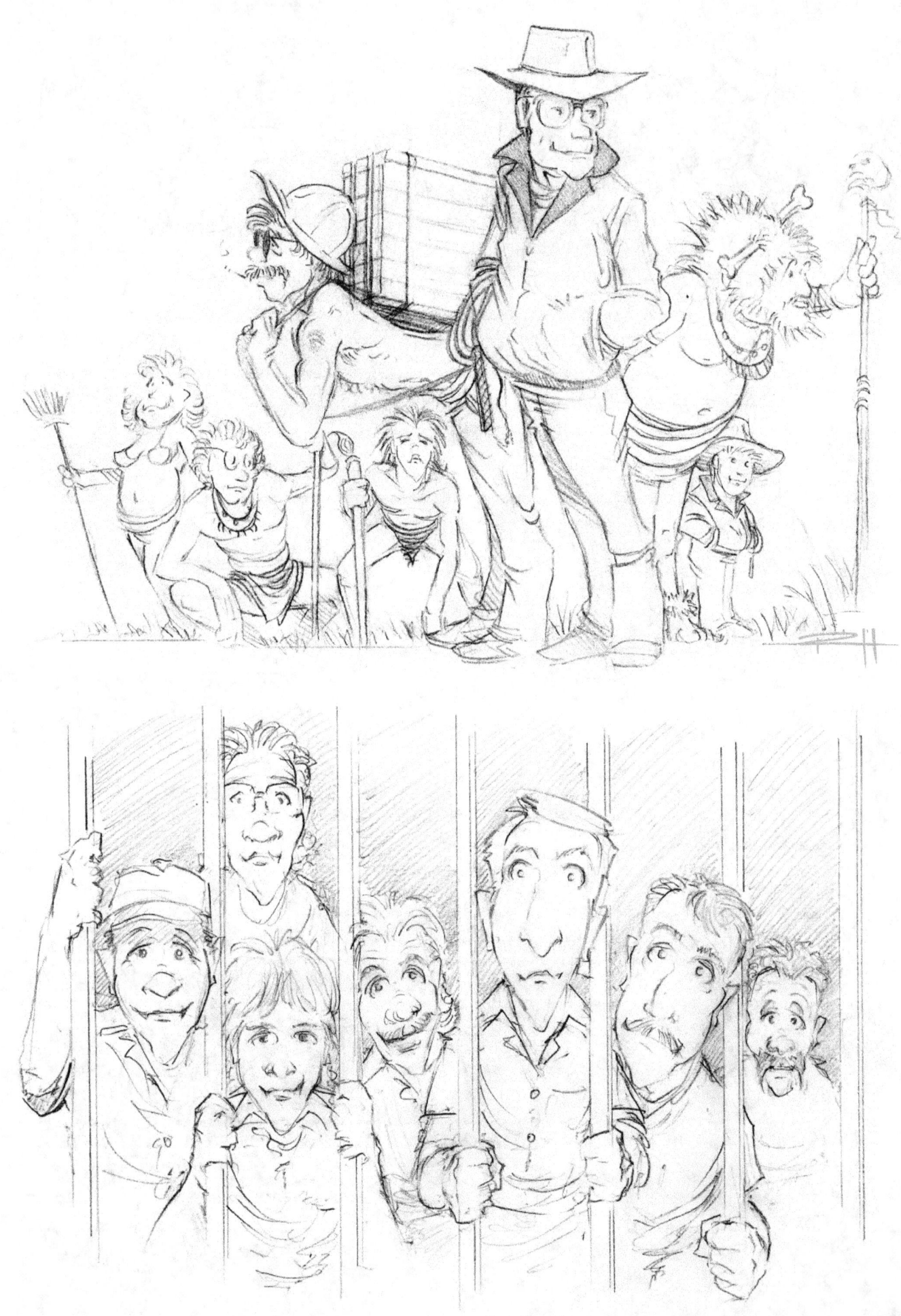

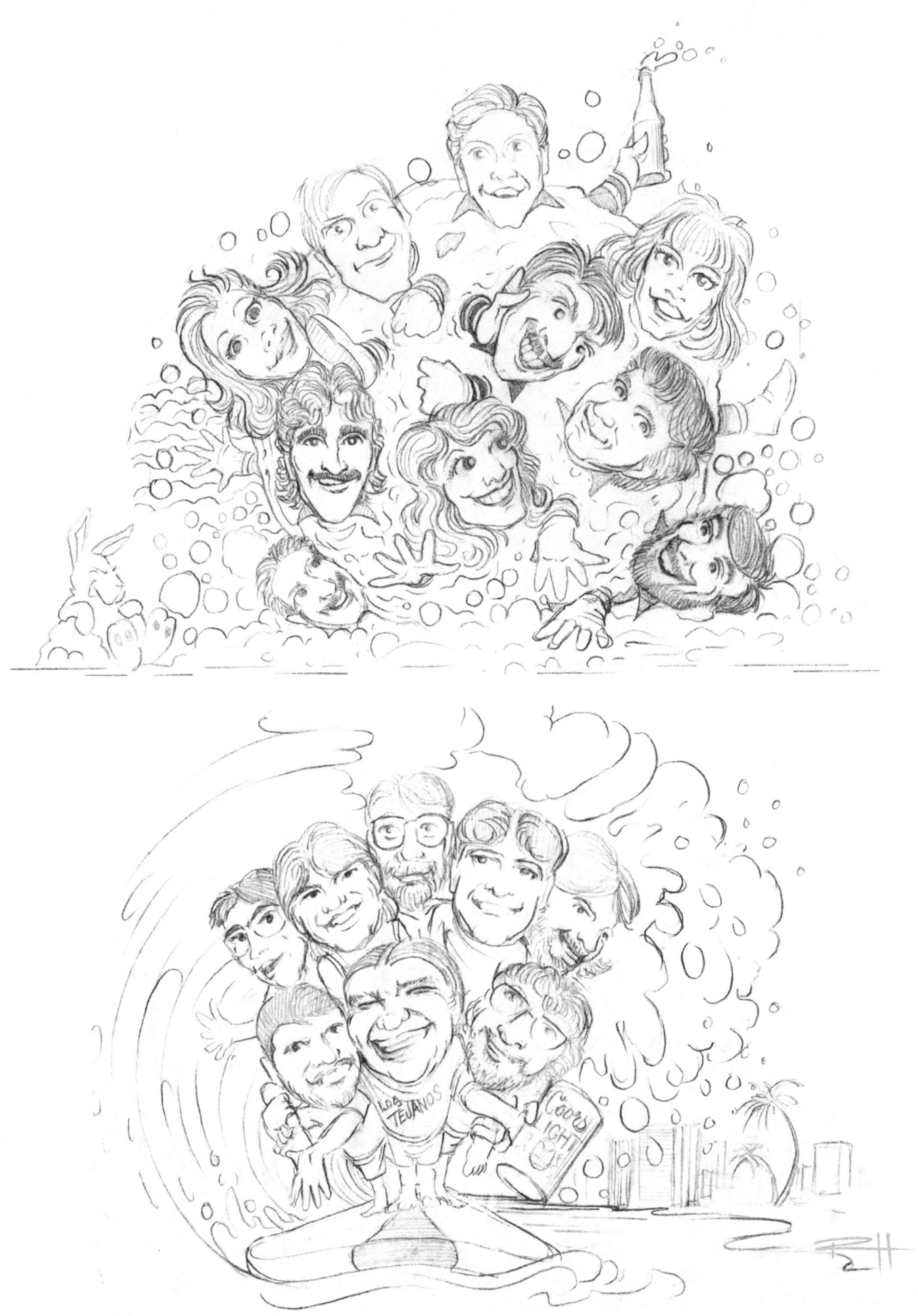

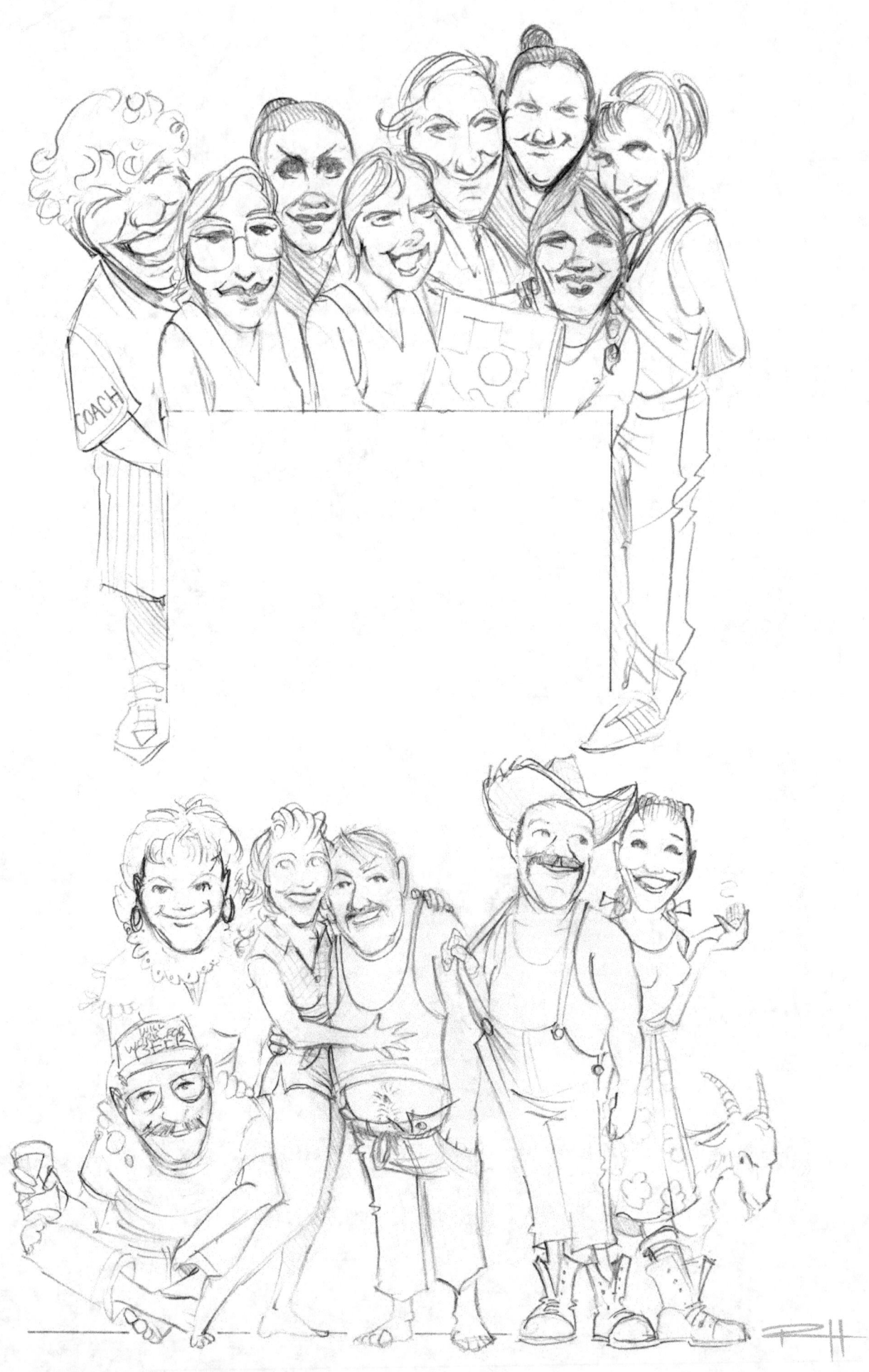

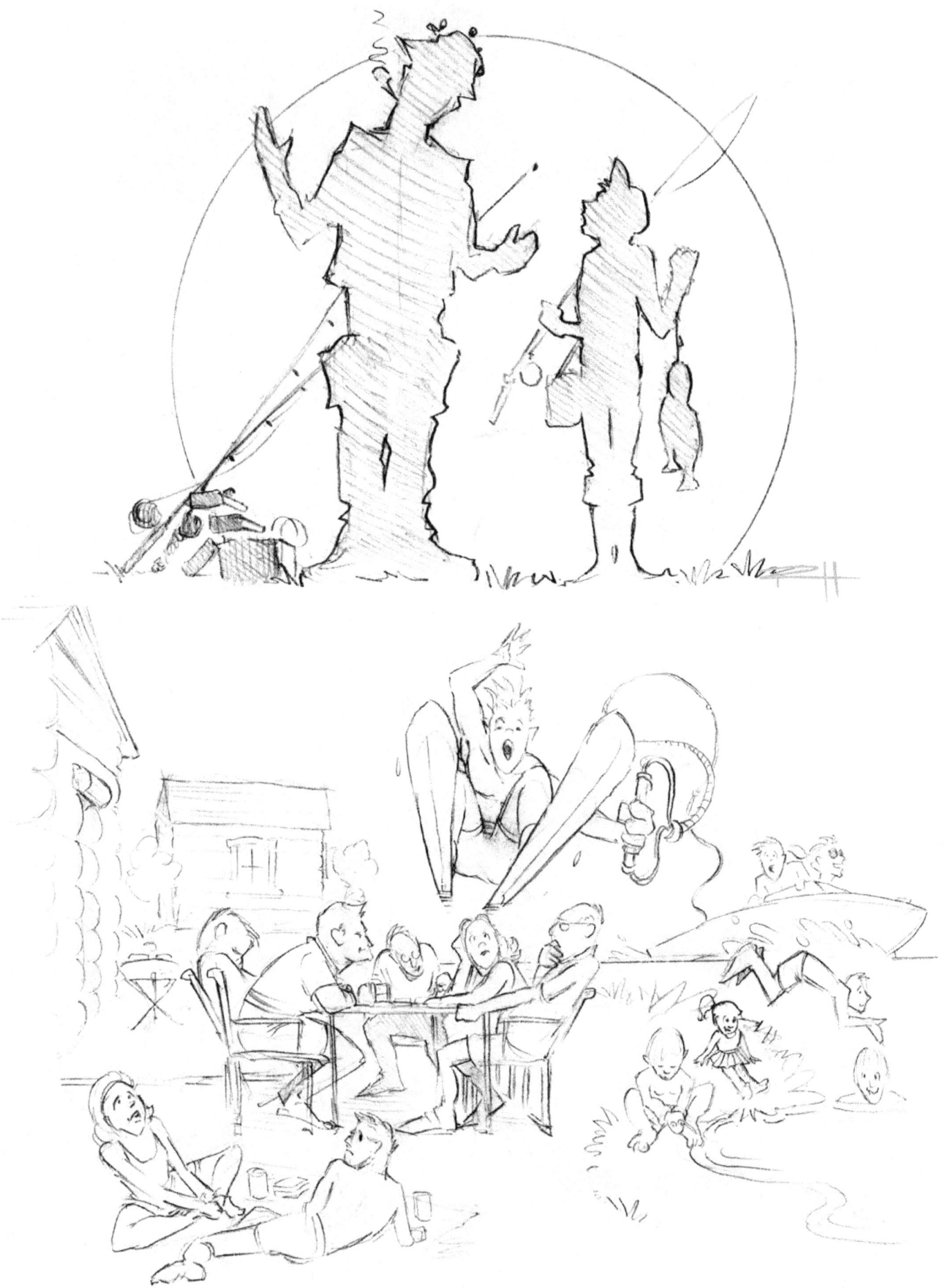

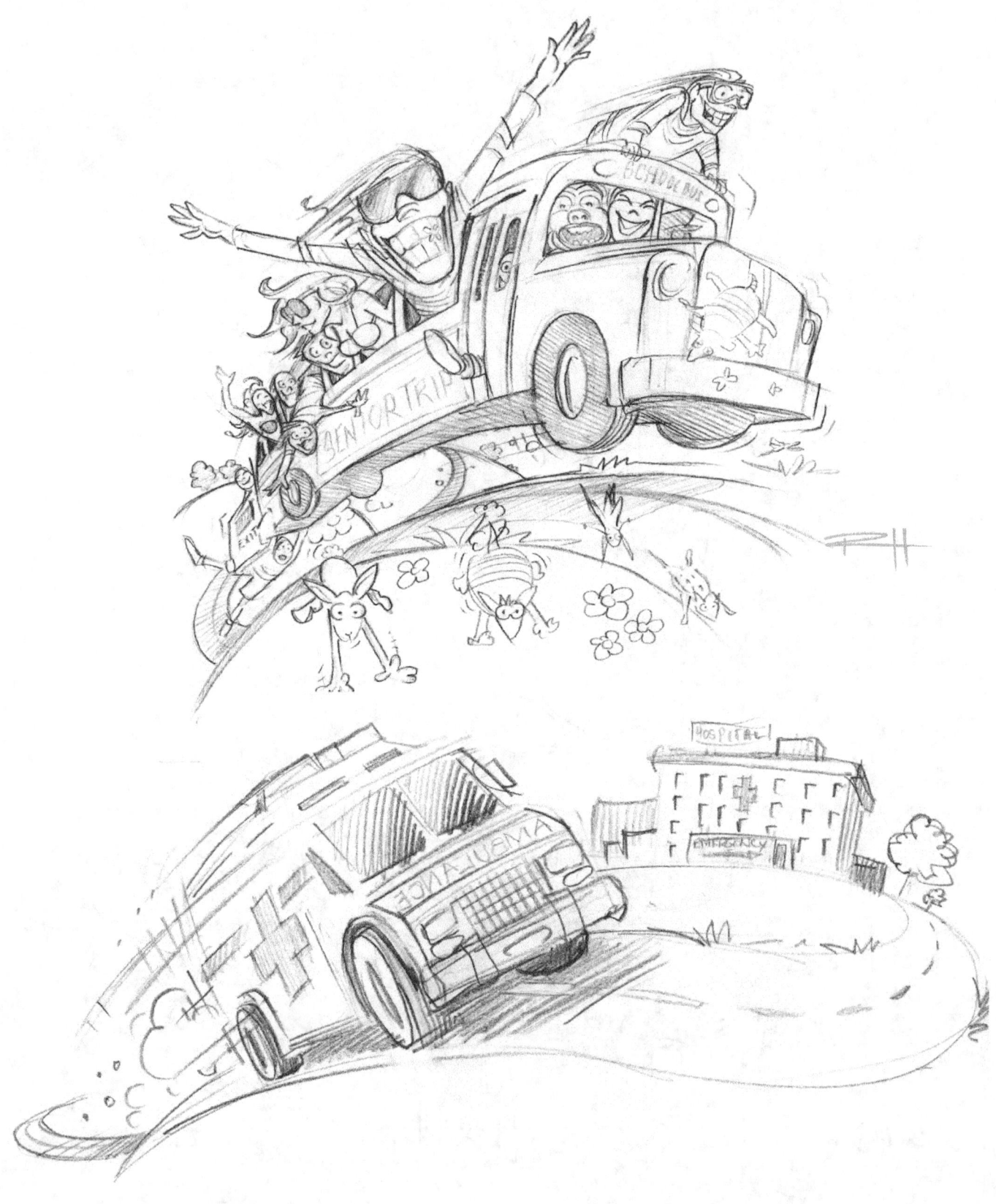

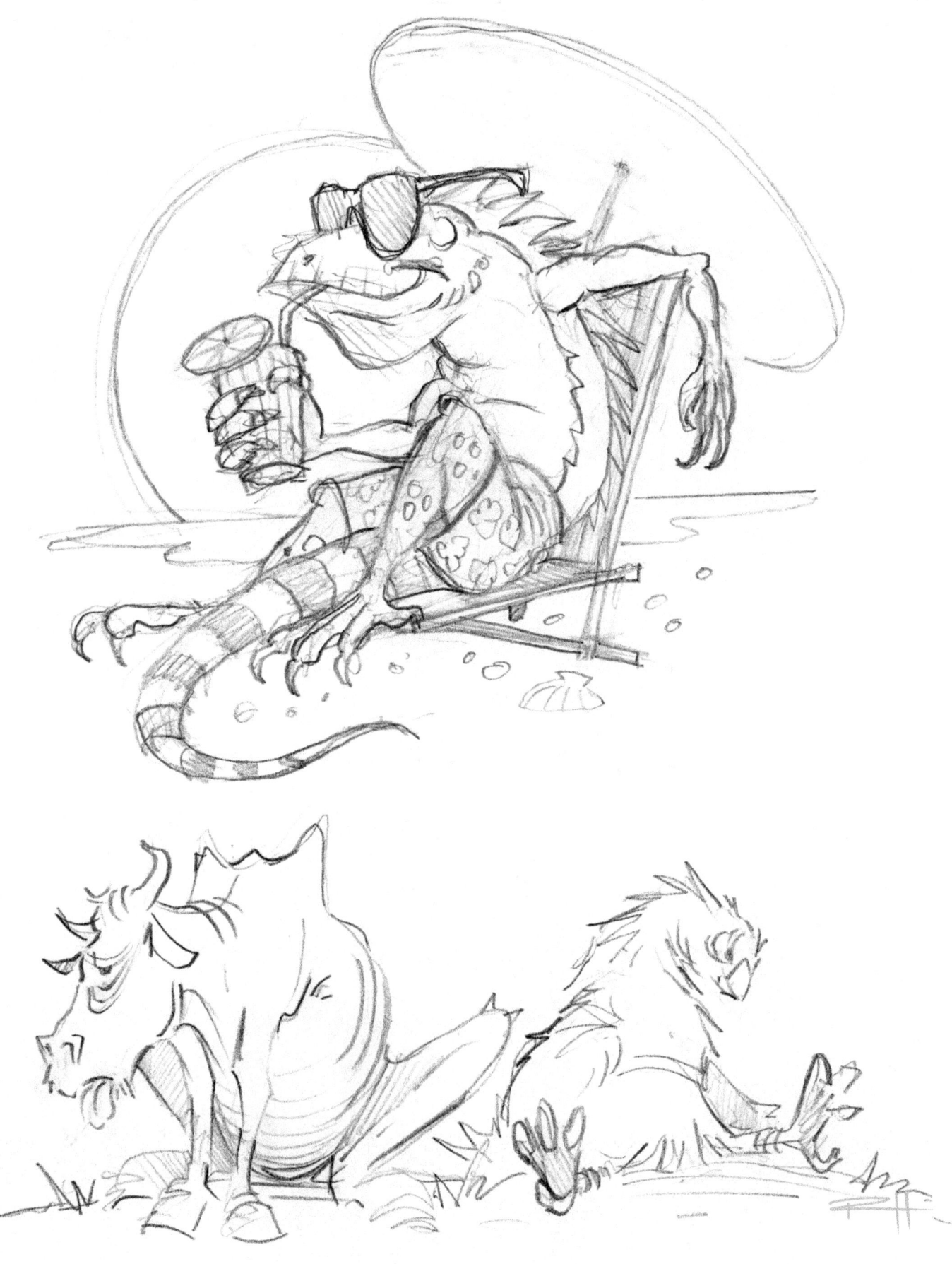

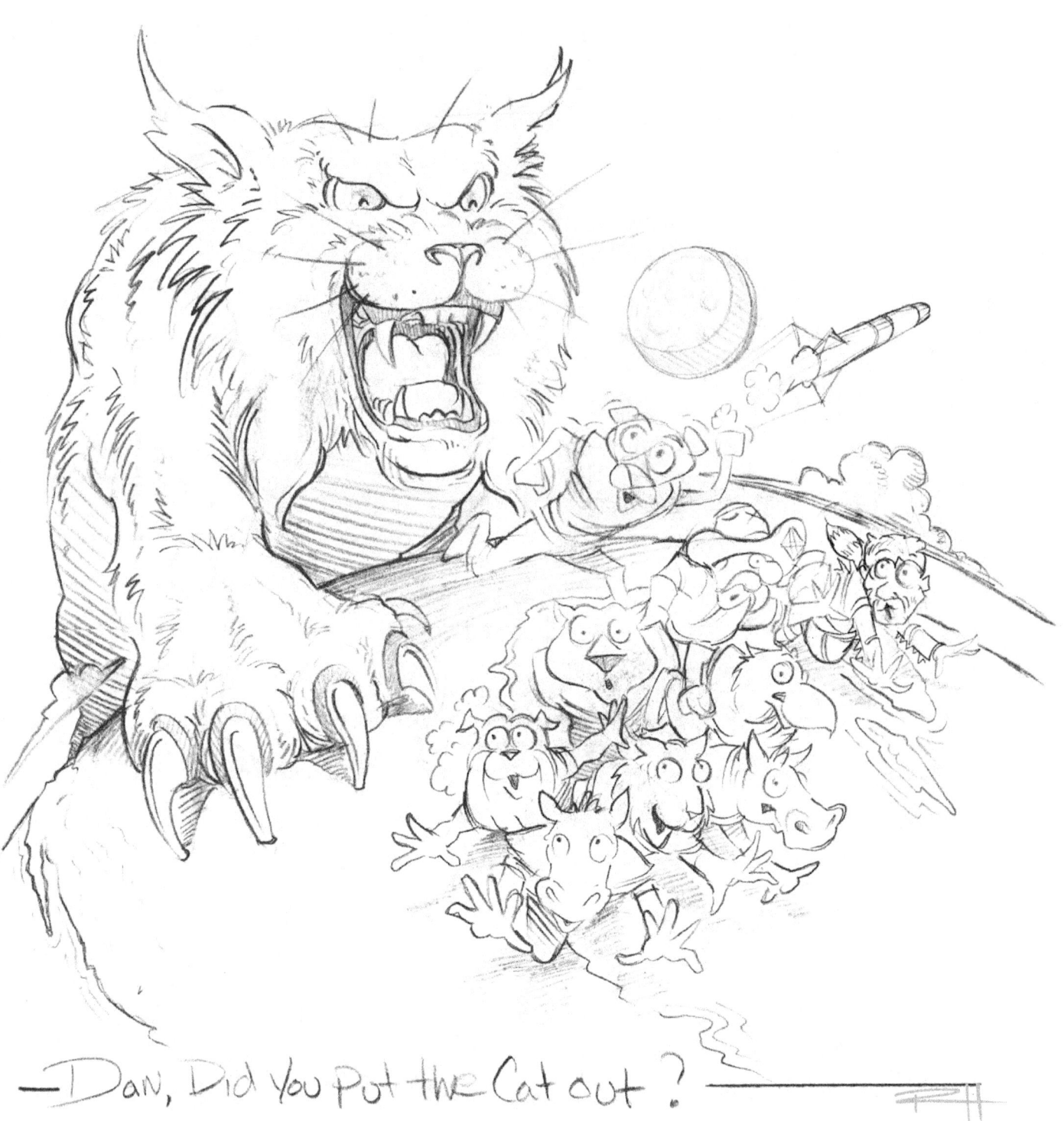

Dan, Did you Put the Cat out?

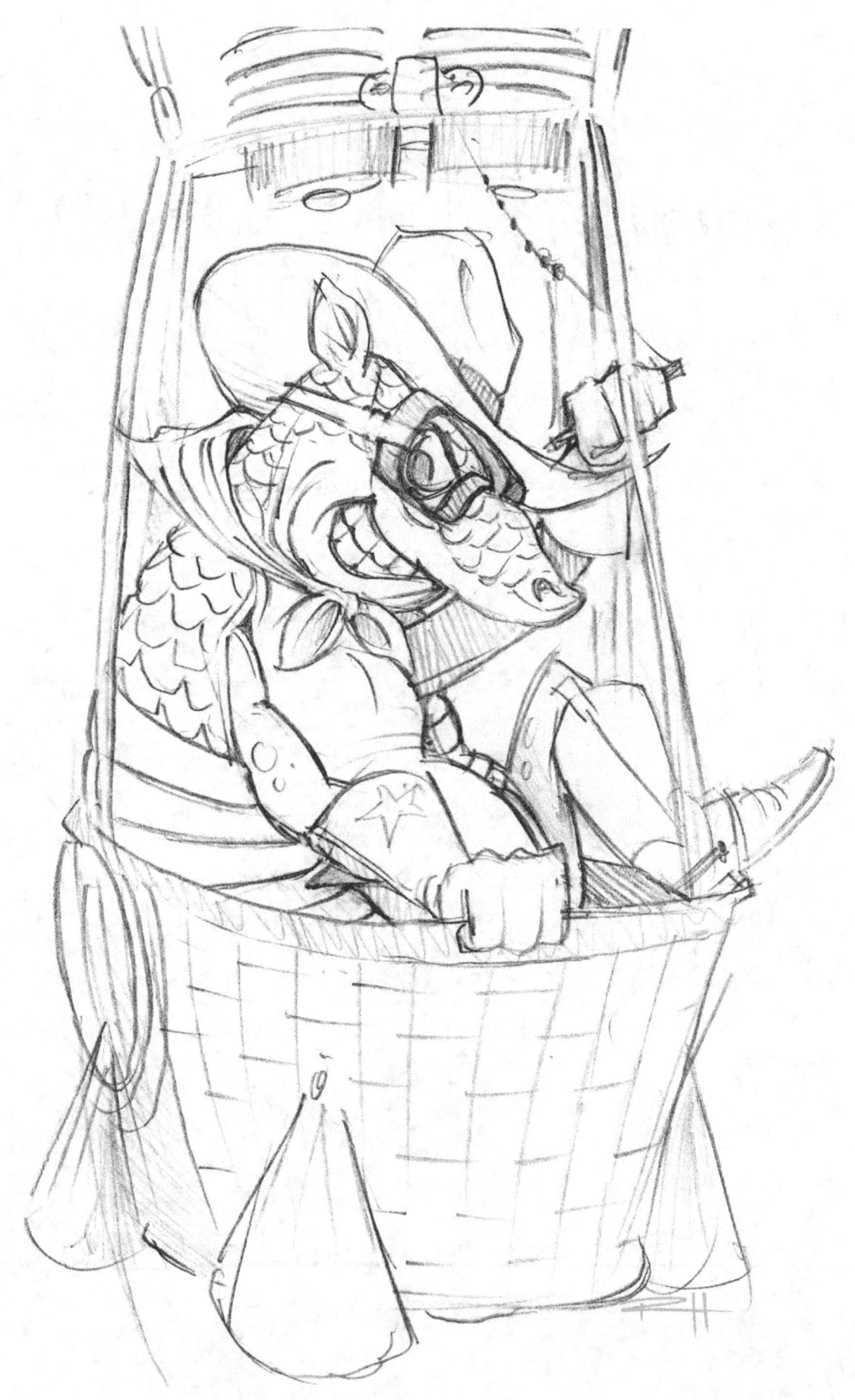

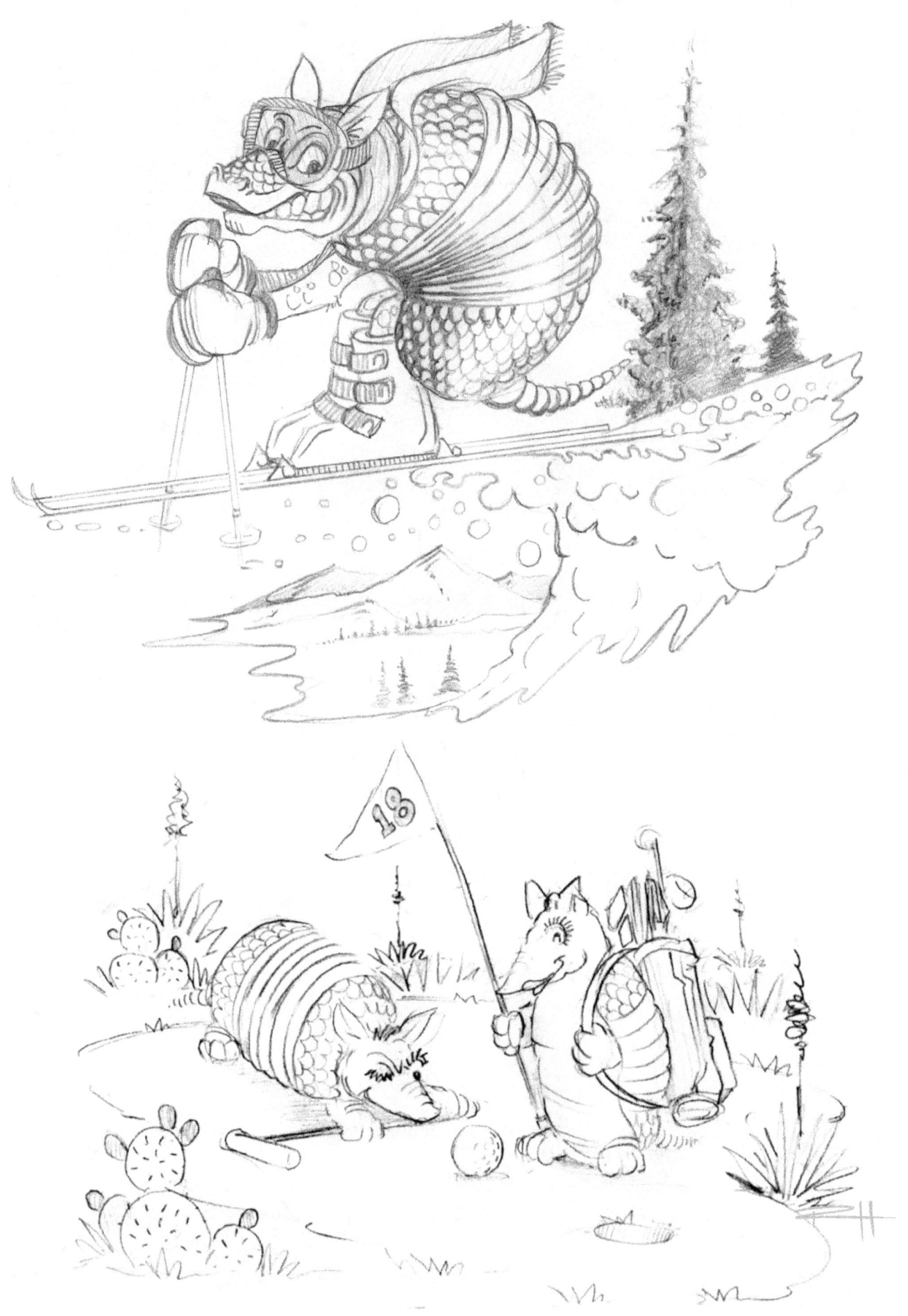

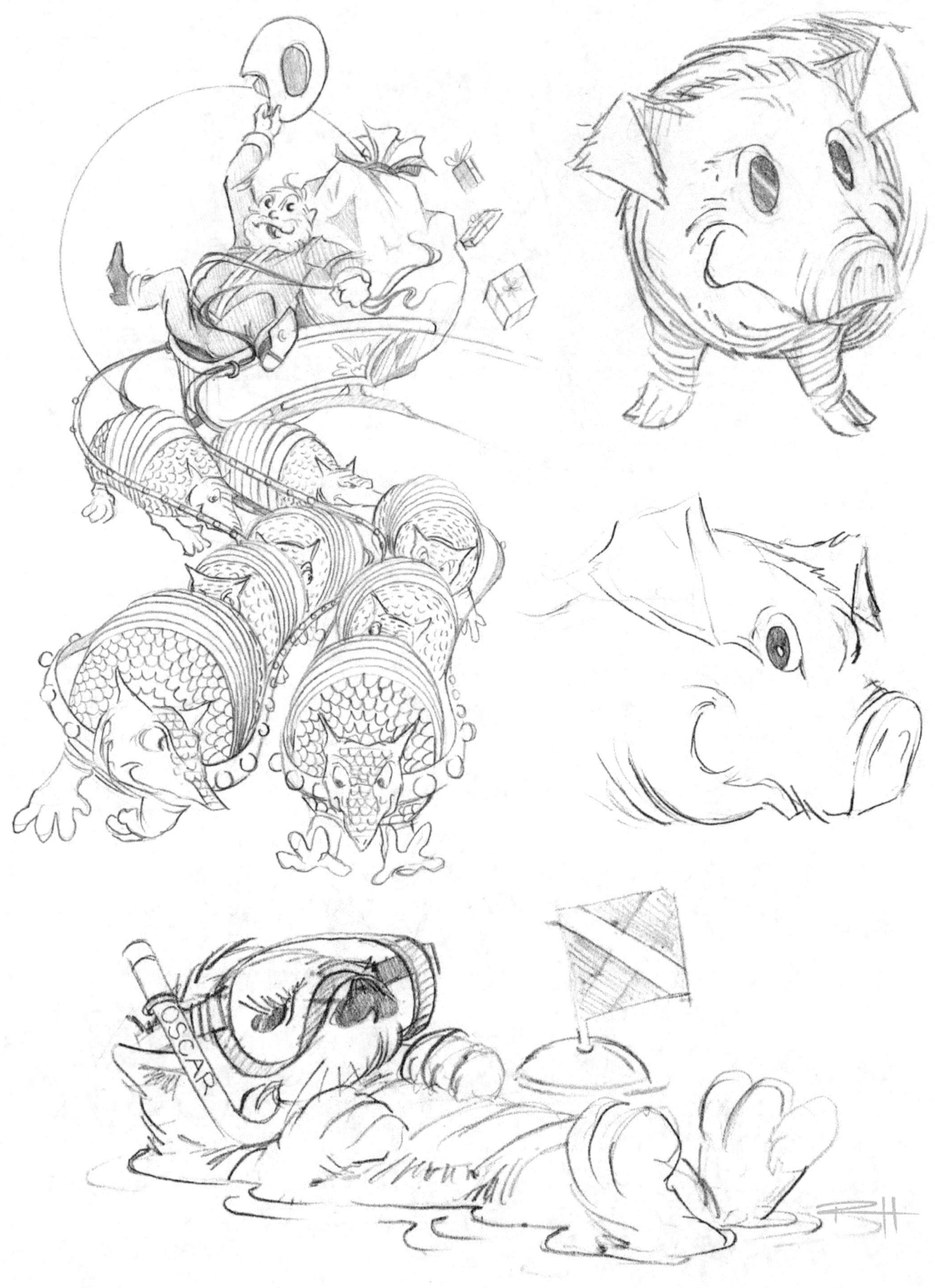

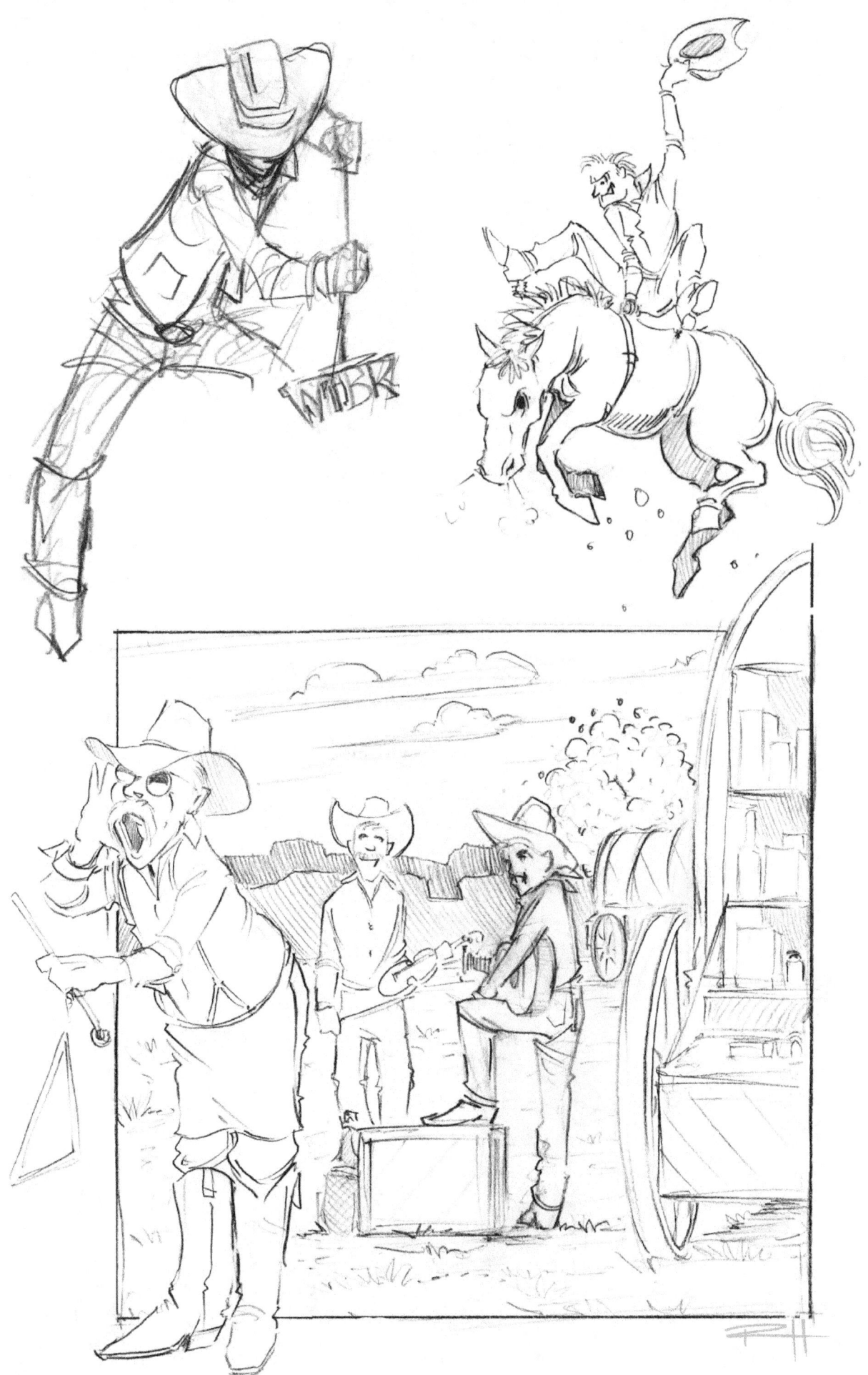

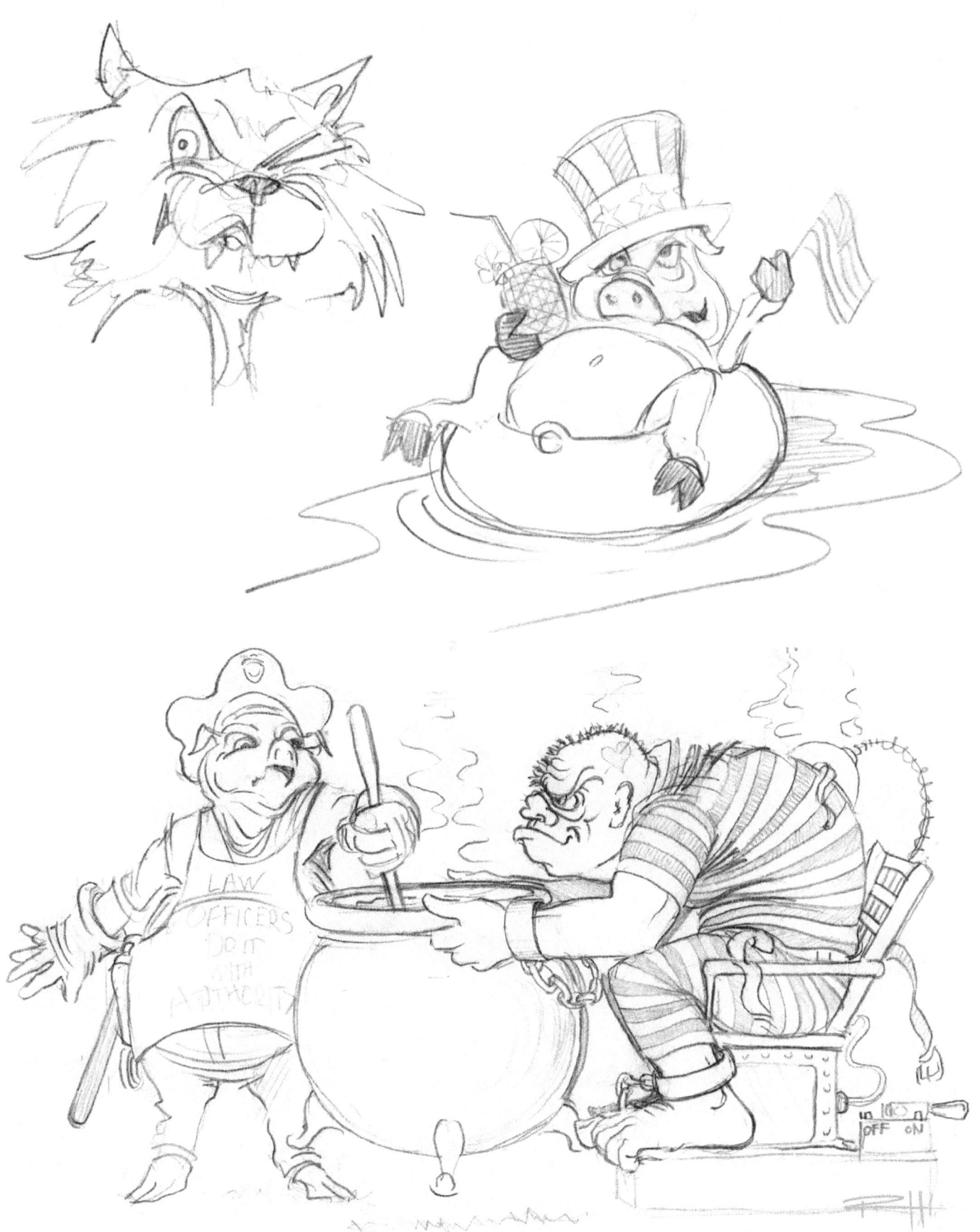

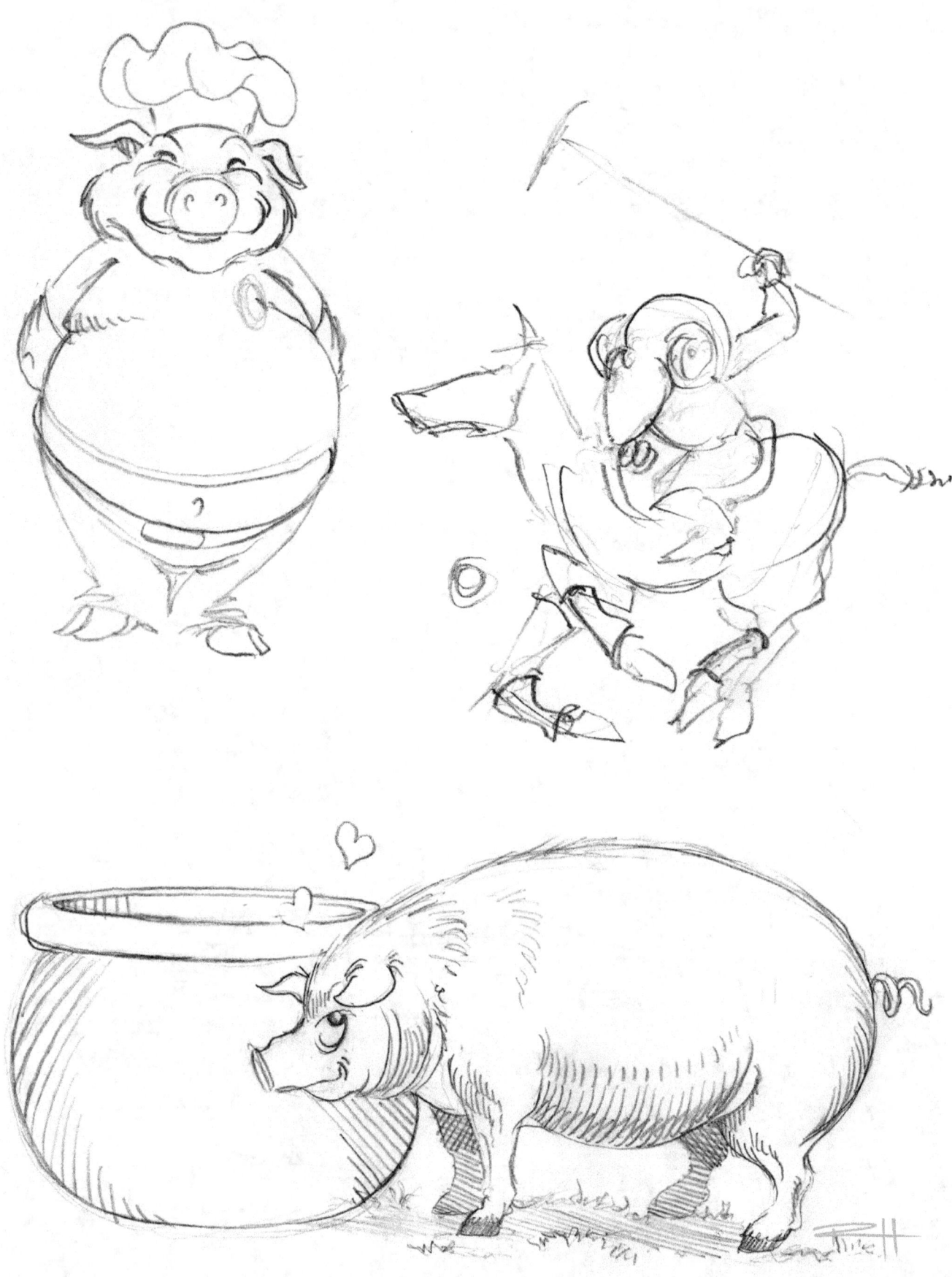

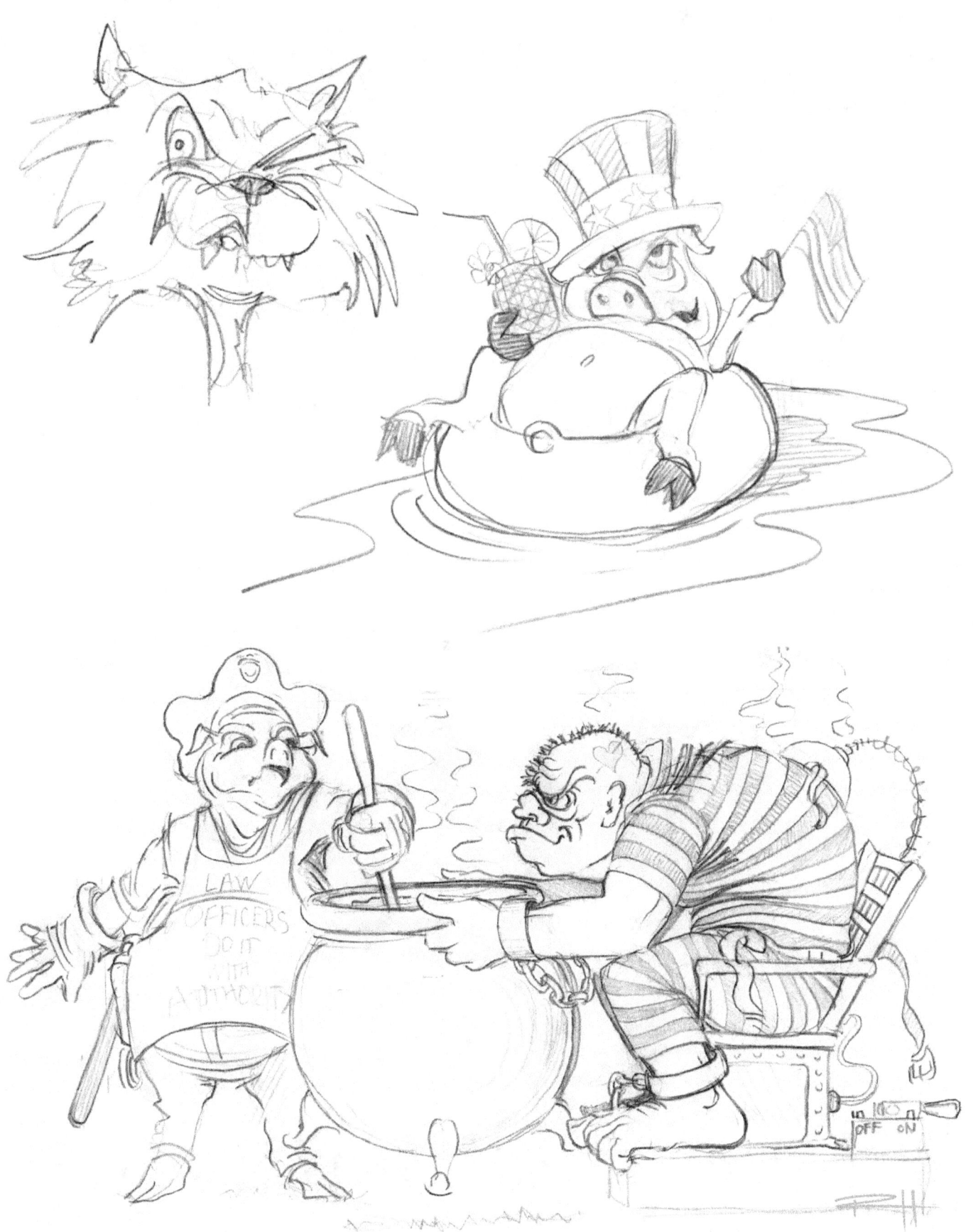

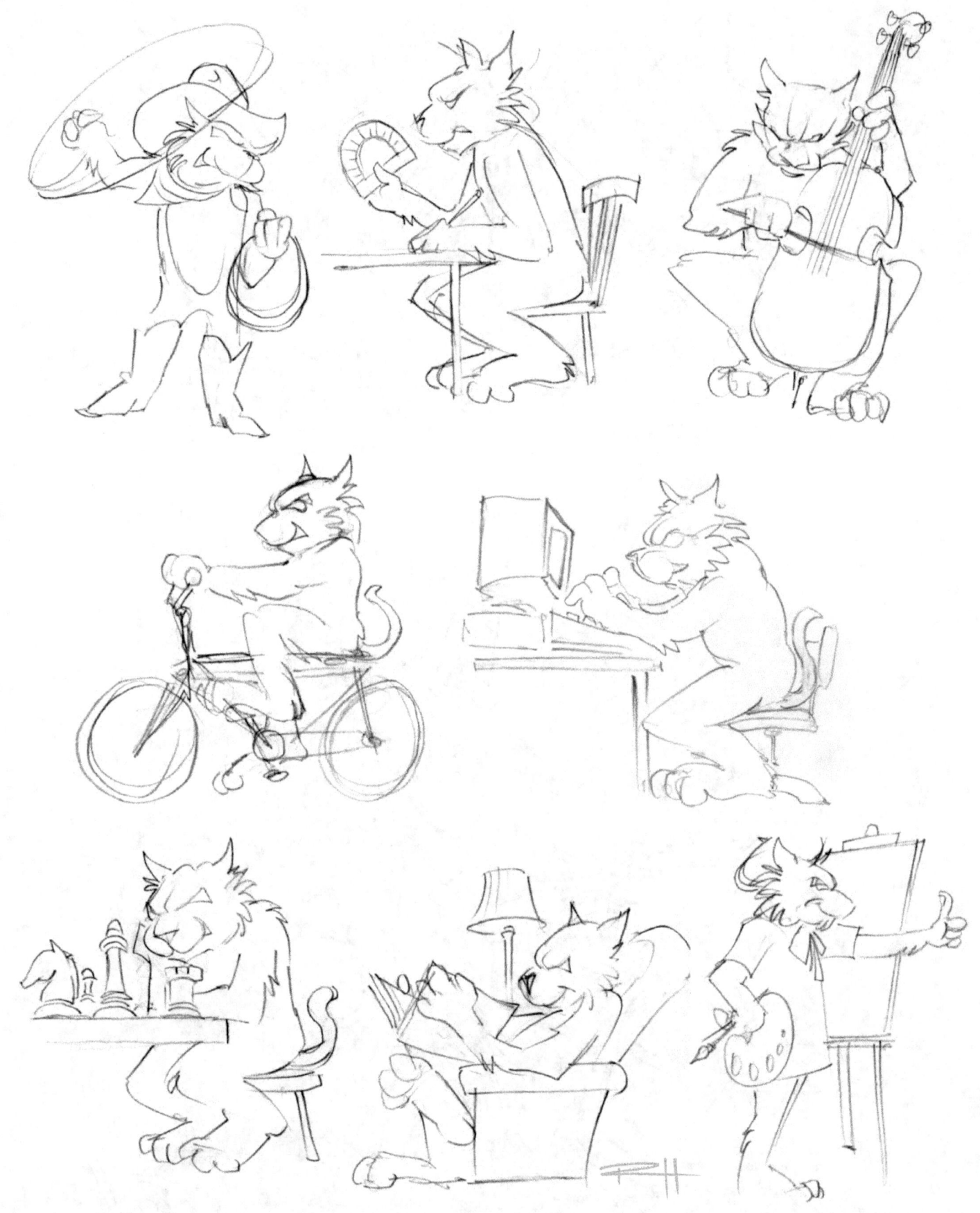

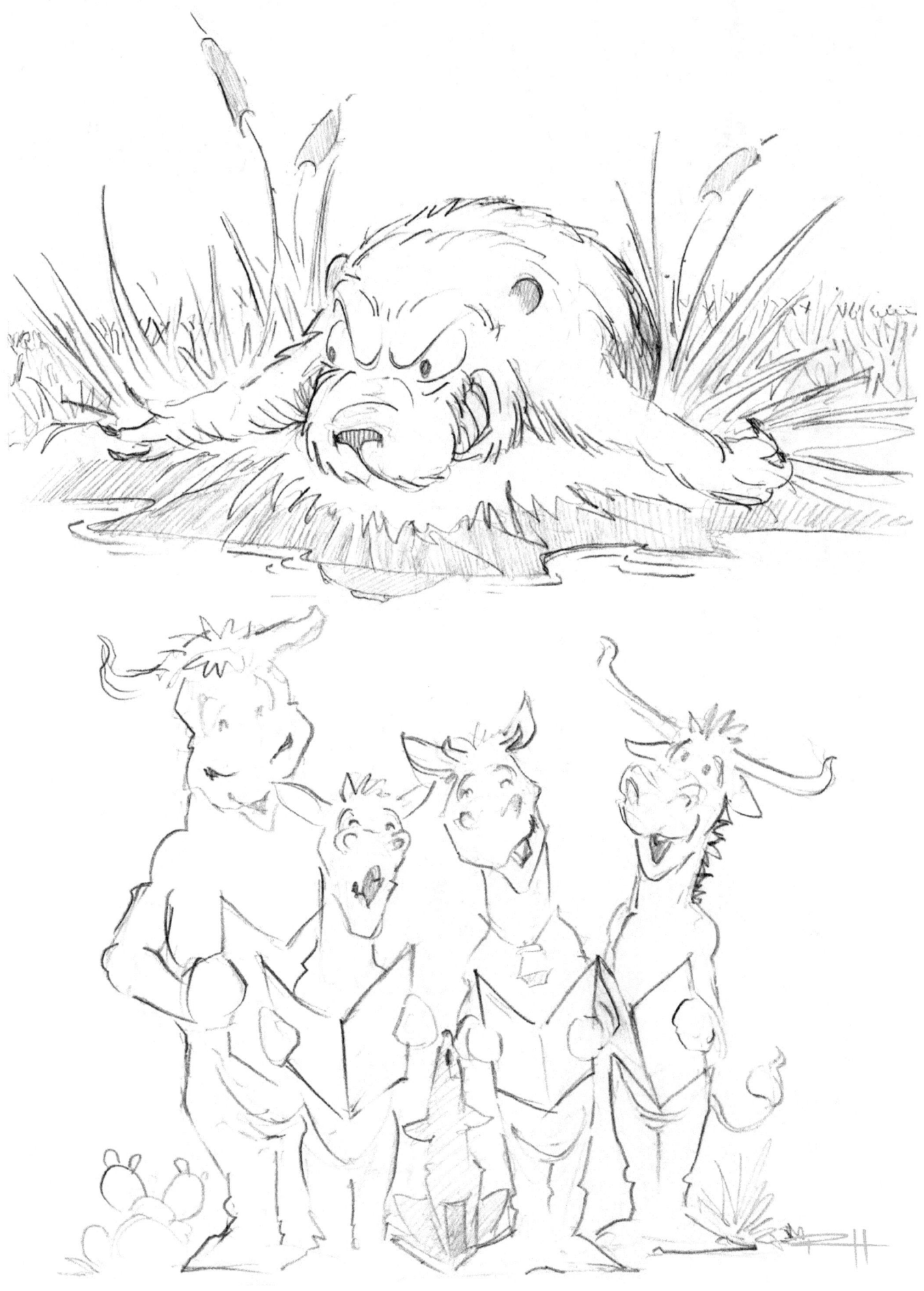

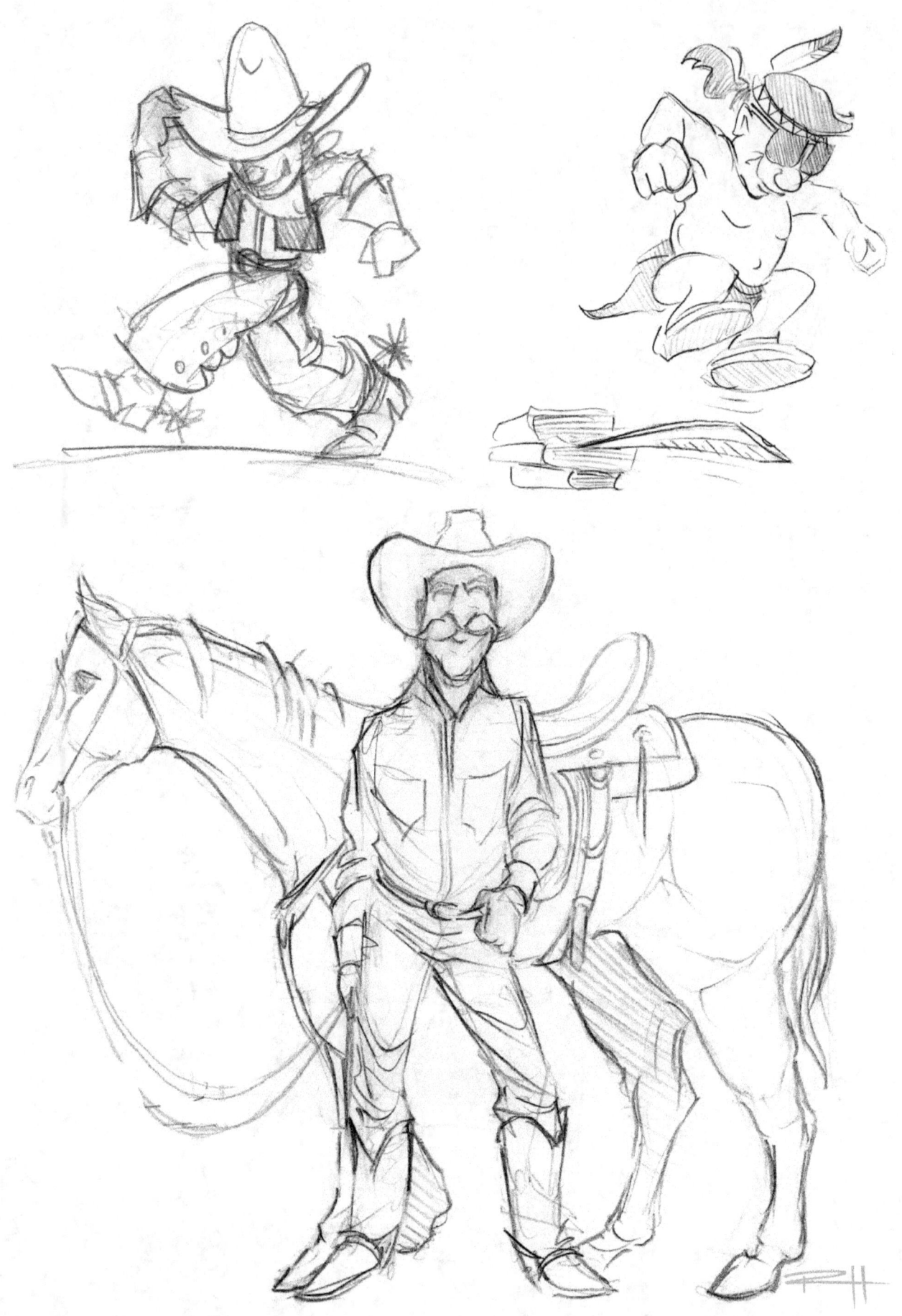

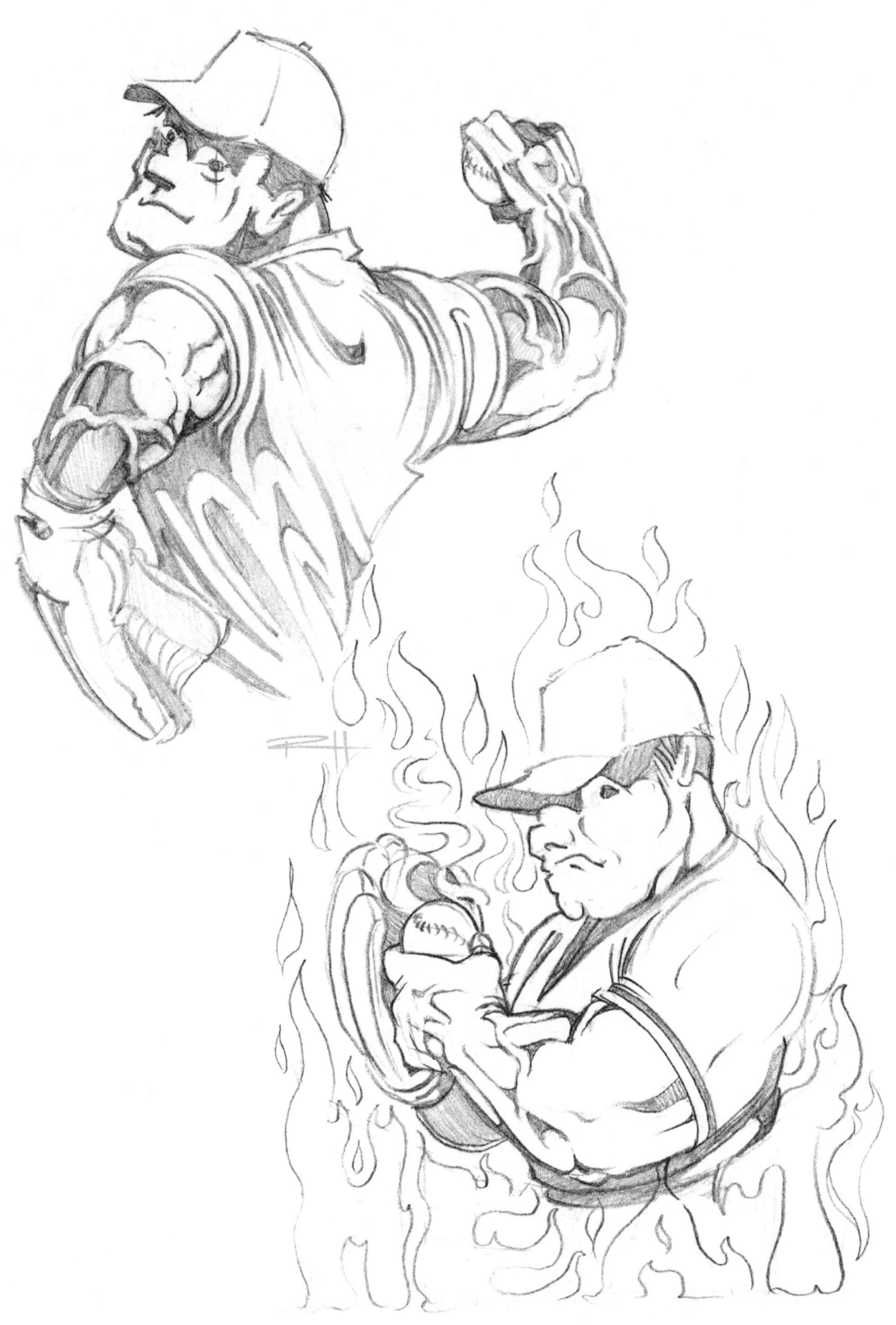

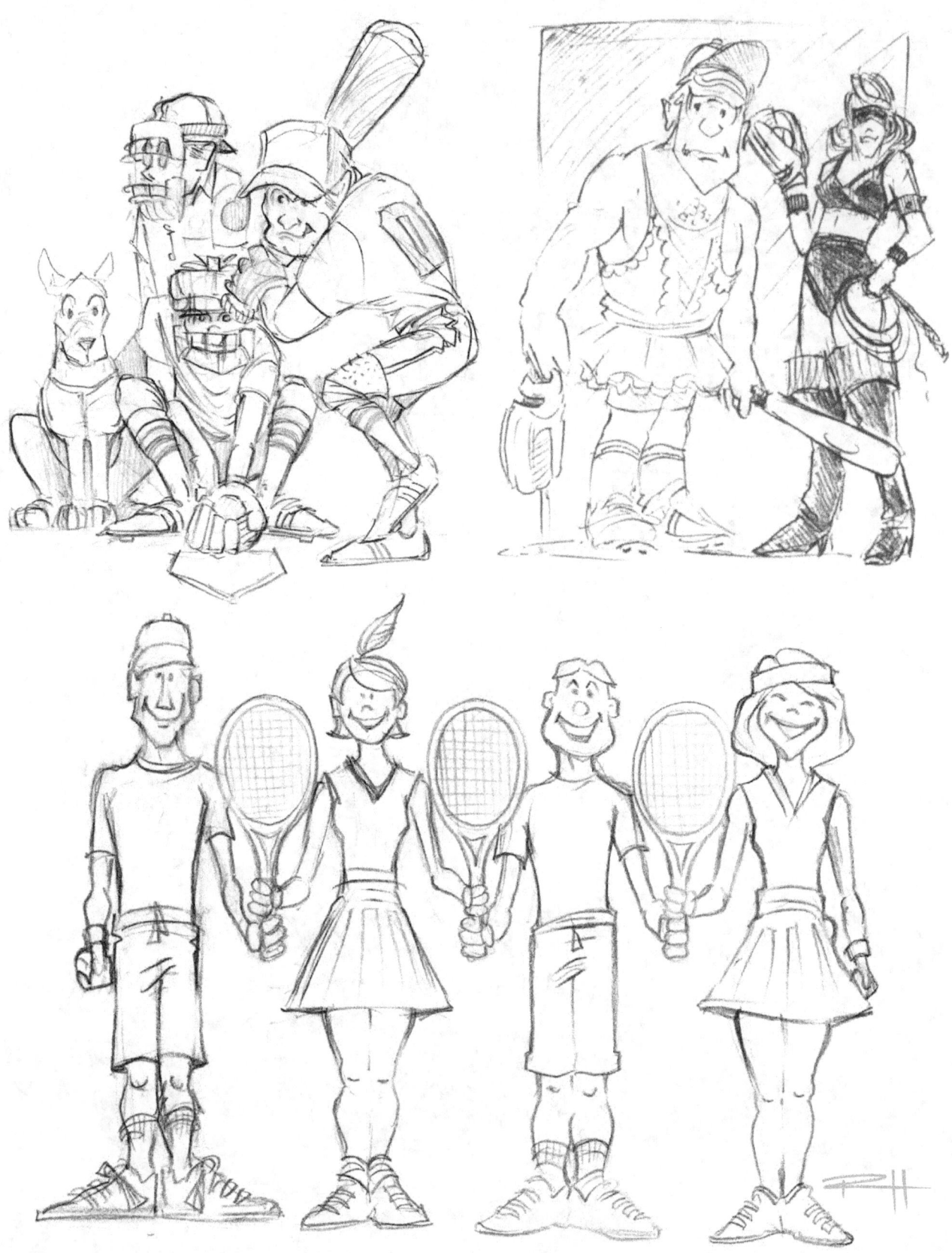

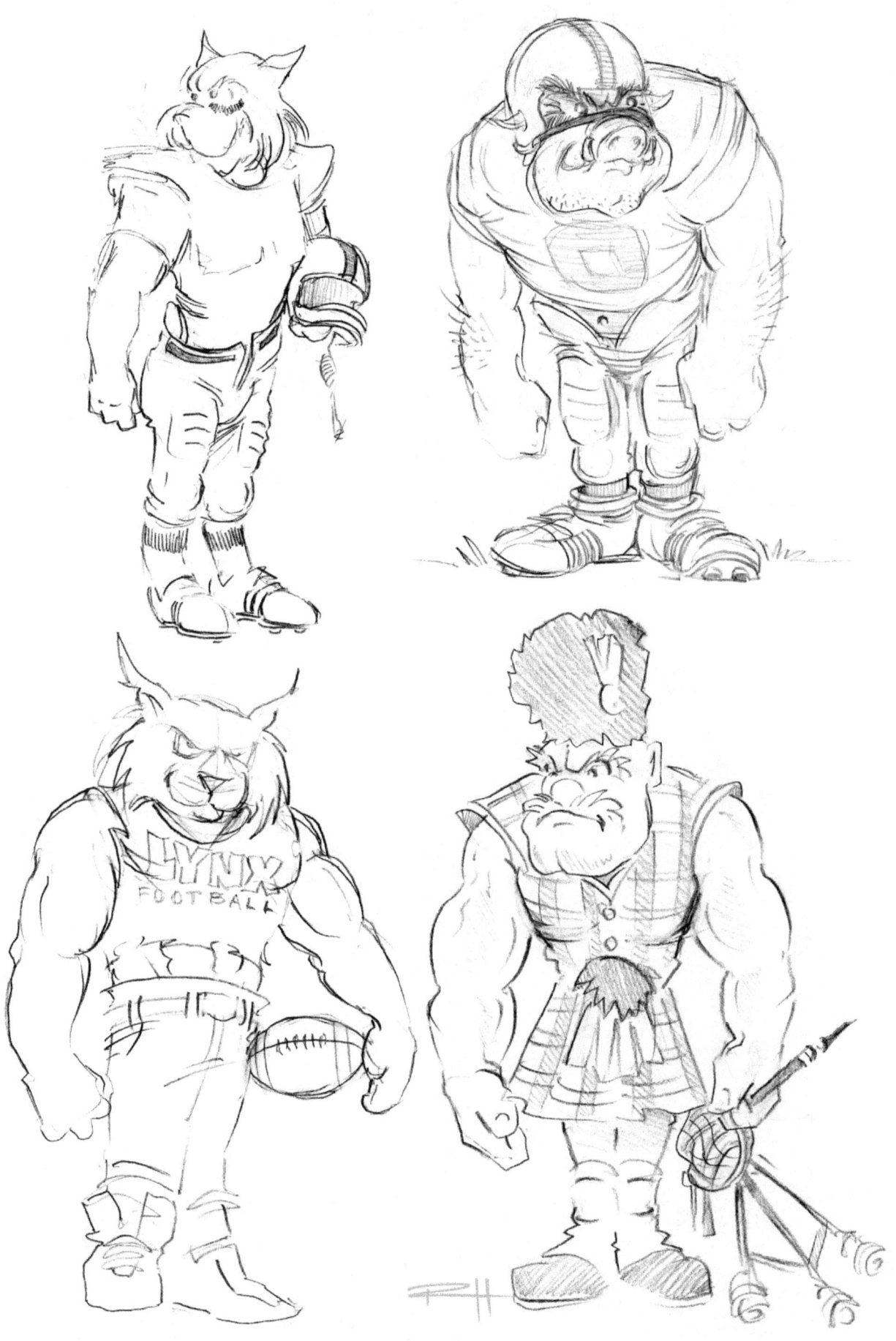

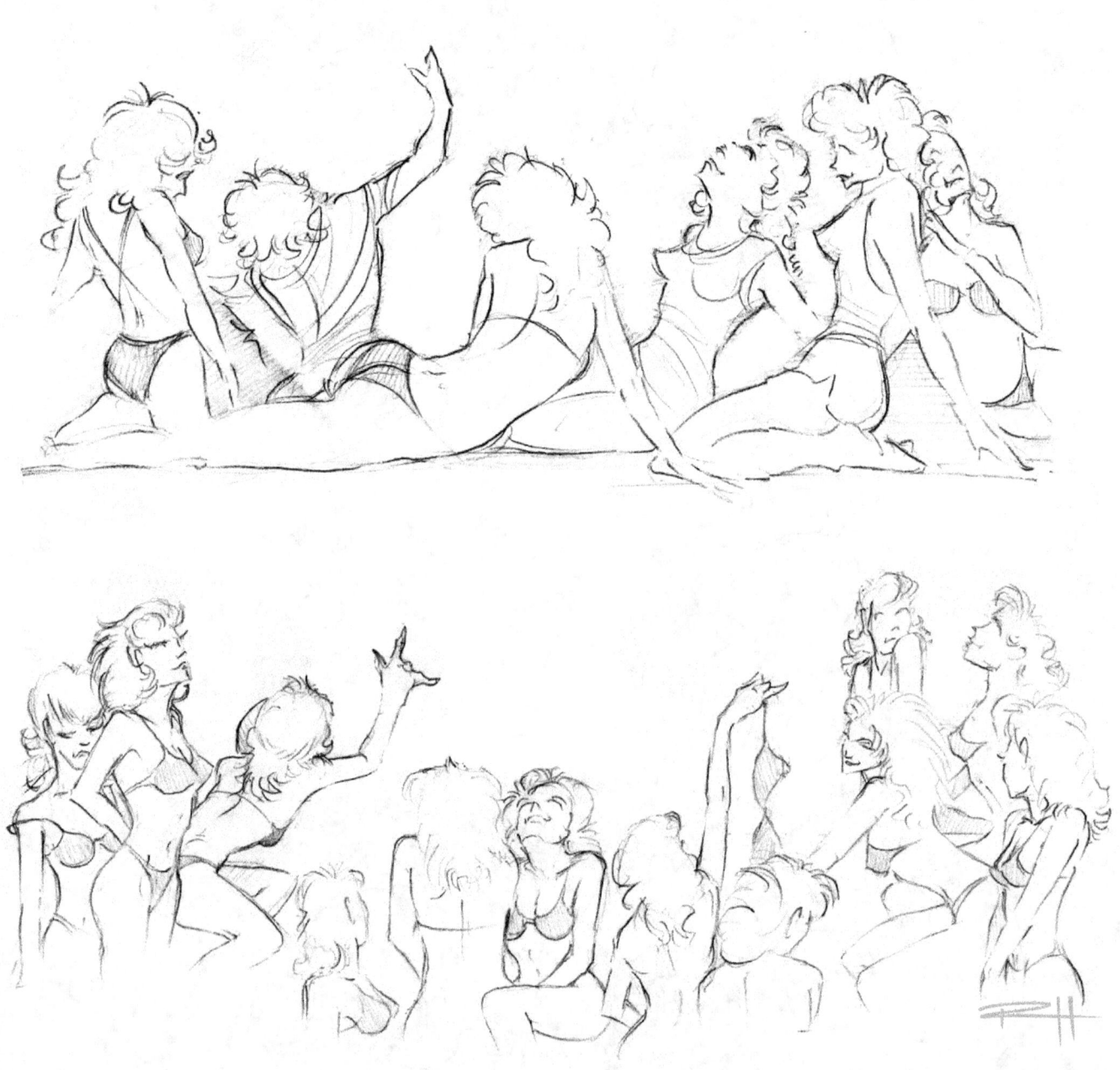

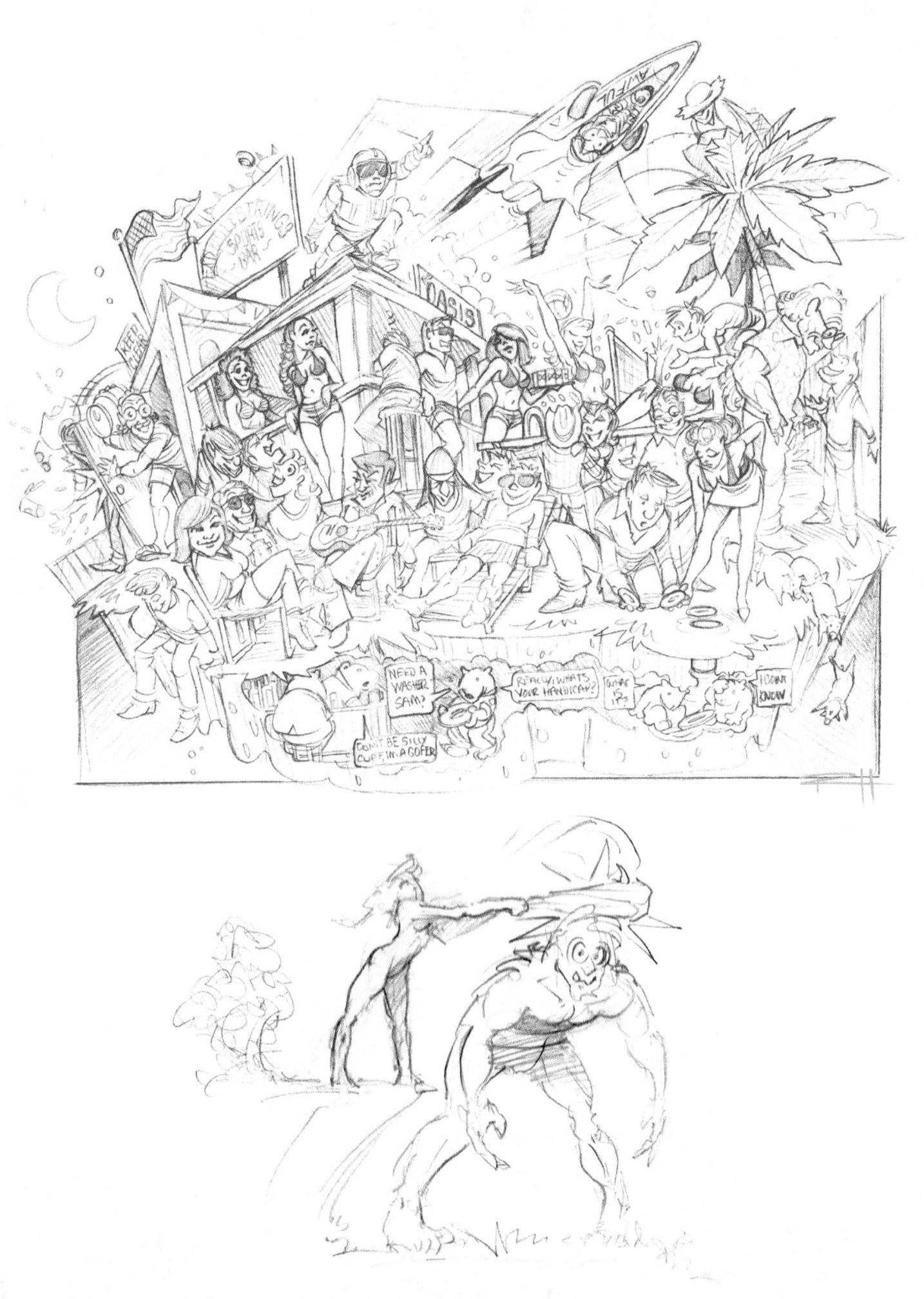

www.ingramcontent.com/pod-product-compliance
Lightning Source LLC
Chambersburg PA
CBHW080942170526
45158CB00008B/2345